High Shelves & Long Counters

Stories of Irish Shops

Heike Thiele photography
Winifred McNulty words

First published 2012

The History Press Ireland
119 Lower Baggot Street
Dublin 2
Ireland
www.thehistorypress.ie

British Library Cataloguing in Publication Data.
A catalogue record for this book is available from the British Library.

ISBN 978 1 84588 752 0

Typesetting and origination by The History Press

Contents

Foreword — 7

Introduction — 12

Gillespie's Pub, Mountcharles, Co. Donegal — 14

Gillespie Tailors, Mountcharles, Co. Donegal — 16

Jack Davey's Shop, Ballintrillick, Co. Sligo — 20

Connolly's Pub, Sligo, Co. Sligo — 23

Travelling Barber, Co. Donegal — 27

Grocer's Shop, Co. Monaghan — 30

Shoe Shop, Raphoe, Co. Donegal — 32

Gambles, Ramelton, Co. Donegal — 34

Hanna Hats, Donegal Town, Co. Donegal — 39

Oatfield Sweet Factory, Letterkenny, Co. Donegal — 43

Iniskeel Co-Operative Agricultural Society, Co. Donegal — 49

Moffat's Shop, Raphoe, Co. Donegal — 53

Quigley's Grocery and Bar, Collooney, Co. Sligo — 56

McDaid's Minerals, Ramelton, Co. Donegal — 59

Johnston's Shop, Blacklion, Co. Cavan — 63

Brennan's Pub, Bundoran, Co. Donegal — 67

Fishing Tackle Shop, Donegal Town, Co. Donegal — 71

Cosgroves, Sligo, Co. Sligo — 74

Curios and Bric-a-brac, Rathmullan, Co. Donegal — 78

Farrell's Café, Manorhamilton, Co. Leitrim — 80

Thompson's Garage, Manorhamilton, Co. Leitrim — 82

Kyle's, Castlederg, Co. Tyrone — 88

Clarke's Butcher Shop, Wine Street, Sligo, Co. Sligo — 91

Coyle's Bakery, Manorhamilton, Co. Leitrim — 94

Henderson's Hardware Shop, Donegal Town, Co. Donegal — 97

Rogers and Lyons Shop, Sligo, Co. Sligo — 101

Garrison Post Office and Shop, Co. Fermanagh — 104

Joe Gallagher, Main Street, Letterkenny, Co. Donegal — 106

Workshop at St Conal's Psychiatric Hospital, Letterkenny, Co. Donegal — 108

Henderson's Music Shop, Derry, Co. Derry — 111

Magee's, Donegal Town, Co. Donegal — 114

Killasnet Creamery, Manorhamilton, Co. Leitrim — 118

Christmas Tree Shop, Donegal Town, Co. Donegal — 122

Acknowledgements — 126

Foreword

A while back Winifred and Heike came to visit me with a book they had in mind to put together, and I was haunted then by the interviews and photographs of the various trades and groceries and bars – businesses that we take for granted – as I am haunted still.

Firstly an exhibition was mounted in Mountcharles. It was somehow the right place for it; and *High Shelves & Long Counters*, as the book is called, is a great title, for we are looking at a history of labour, of loneliness, enjoyment, frugality and determination. Milk and butter, shoes, hats and suits are the heroes, as are those women and men that threw open the doors of the hardware shops and bars and creameries first thing in the morning, and then swept up last thing at night. The details are often intimate, and historically painful:

> In the 1950s there was huge emigration, we used sell a lot of suitcases, they came from Dunleavy's in Donegal town. One day we sold 15 suitcases to 15 young people going to America or Britain.
>
> Johnston's shop, Blacklion

The photos by Heike echo this sense of loss, with the deserted creameries, old stairs, empty shelves, and sets of bills pinned to the ceiling. A rare record of the past is being unfolded. Files going back in time fill a desk. Mahogany counters abound. The clutter and hard work of the shoemaker's room is shown in stark contrast to the rich display in the shoe shop and the shot of the metal shoe last is extraordinary.

> My favourite shoes were a green pair; I would not give them away for gold.
>
> Jan Patterson

The interviews Winifred has conducted are short and directly in the person's voice, and capture the past with such precision that the disappearing world being recorded re-enters the consciousness and reappears in all its physicality.

We keep the wheels turning, summer time is a quiet time but winter is busy with animal feeds, coal and gas ... I started here on 26th of January 1970 ...There've been tough times and good times and sad times, you get that in life, that's the way it is for everyone.

<div align="right">Paddy Mc Monagle, Iniskeel Co-Op</div>

In putting that show and this book together in remembrance of the last of the old shops in the North West of Ireland, Winifred and Heike have travelled Donegal, Tyrone, Leitrim, Fermanagh, Sligo and Cavan as part of their project, 'The Story of Demand'. So the accents vary, the goods sometimes differ and we encounter countless lives on the journey; suits travel to Tory Island from the tailors Gambles in Ramelton, islanders gather for tea and scones in the tailor's and farmers gather round a big oil heater in the middle of the shop on Saturday nights.

With an air of serenity he pulled the chrome frame over and back until the rhythmic cutting echoed like a pendulum in the silence of the shop as each slice of ham fell onto greaseproof paper. 'A half pound, will that be all?'

<div align="right">Jack Davey's shop, Ballintrillick</div>

Community life in this rare publication is given a fresh airing, and that is one of the strong elements at the core of this fusing of the visual and the oral. As we turn the pages and look at the photos we can hear the voices in the background.

We make all types of hat, each has a story and reflects something of the natural landscape around Donegal. 'The Barnesmore' has the colours of heather. 'The walking hat' is indestructible, you could bail out your boat with it, there's 'the vintage hat', 'the lug cap' to keep your ears warm and 'the newsboy' an eight piece cap, we have pictures of Pavarotti wearing his.

Terry O' Sullivan once asked Dad, 'How long do you think these hats will last?' He replied, 'As long as people have heads.'

<div align="right">John Hanna, Donegal Town</div>

The bottling of Guinness and Whiskey is recorded in Quigley's, the camera heads round the shop and the bar and you are sitting down at the back listening behind the lens. The photos are intimate, old shops have gained an incredible witness as Heike snaps down to the core, to the small reel of rainbow thread;

the hammer by the white shoe and the busted wall. She is bringing us into the mental and physical life of antiquity.

> The shop was full of psychology, the people coming in and out were fabulous, they had more psychology than people with PhDs, the people had a natural wisdom … I would've changed nothing. I couldn't change it; it was the way it was.
>
> <div align="right">Mary Mc Granahan, shoe shop, Raphoe</div>

Winifred McNulty and Heike Thiele have put together an extraordinary combination of what the eye sees and the ear hears. It's great to look at and read their work. I'll end with those great shots of the butcher, a man I know well, going about his business in Wine Street, Sligo:

> When I'm gone from here the show will be over; you wouldn't wish it on your worst enemy; it's cold heavy work.
>
> <div align="right">James Clarke, butcher , Sligo</div>

The real has rarely being presented with such artistic authenticity.

I want to congratulate the two artists and wish them success for all that happens down the road as this book enters the public arena.

<div align="right">*Dermot Healy, 2012*</div>

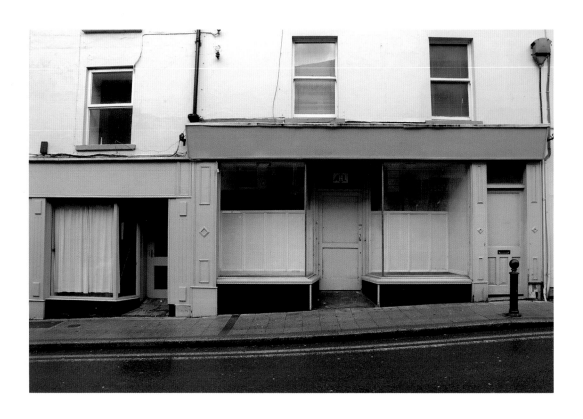

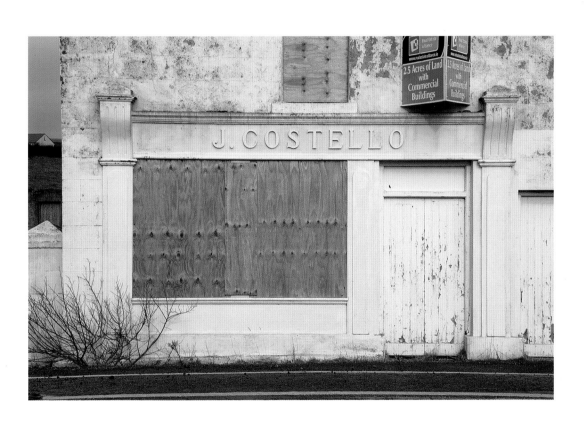

Introduction

Wandering along the streets of a small town, you might peer into the window of an old shop. Look past the yellowing paper in the window to the distant shelves with cups and saucers, the old sweet tins, and the out-of-date toys. On the floor, there's an ancient stand-alone freezer, its cream top open and rusting. You might remember ices being lifted out and small square blocks of ice-cream being fitted into a wafer. On the counter there are curling postcards. If you could push open the door, a bell would ring somewhere in the hollow of the house and make shadows move behind a glass door as the shopkeeper steps out from the room behind the shop.

This is the story of old shops, groceries, draperies, hardware shops, shoe shops, creameries; the stories of shops you remember or perhaps thought had disappeared. In Ireland, accelerated change over the past thirty years has spelt the demise of the fair day and the disappearance of old shops, and there has been a move away from shopping in local villages in favour of bigger towns and supermarkets.

Many people will still remember a time when white 'shop' bread was a treat and vegetables and milk were items you supplied for yourself. The customer books in the 'Cope' record a litany of repetitive requirements: tea, sugar, flour and oatmeal.

Heike and I set out in 2007 to make a record of these old family businesses. Long before we met, we had already begun. Heike had taken pictures of Magees and Charlie Doherty's fishing tackle shop and I had written about Jack Davey's shop. We started at the eleventh hour; construction machinery was crashing through the streets of country towns replacing the old houses with airy new shops, many of which are still empty. We set out each Thursday, as though travelling back through the years, to these calm spaces, delighting in the openness of the shopkeepers who let us explore and record their shops.

On the upper storeys, where his grandfather made suits, Andrew Gamble showed us letters written by customers making arrangements to pay for goods in the early years of the last century. Tony Gordon unlocked the abandoned creamery office where we found 'intervention' butter boxes, still lined with blue paper, and glass test tubes, waiting for the milk and butter that would never be made. In Dunleavy's in Mountcharles, we stepped into a ware room where linen was finished, a saucepan of 'blue' still on the floor.

Many of the shops have closed since we began the project; shops that have witnessed a century of changes have quietly bolted their doors. The shops that remain and thrive have capitalised on their specialist, individual products, sometimes selling goods worldwide.

The glimpses into these shops leave an imprint of an older quieter time, when ritual and a sense of community were part of shopping. There is a sense of a spareness of needs, the sense of existence rather than choice. Shopping had not yet become so tied up with our sense of ourselves and our lifestyles. For most people, it was 'a plain tea or a meat tea'. Yet what you bought might still reveal something about your life; cakes and ham and an extra loaf might mean visitors, or a suitcase, emigration.

Crusty sailors smoking 'Walnut Plug' and spotty dogs advertising washing powder are still in working shops, where small children come and sit on a red bench and select sweets to fill a brown bag and have it twisted closed for them; their first transaction a small step to independence.

Memory lives in the fittings of these shops. The wooden counter is polished mahogany. The original fittings, made by the original owner, are covered in generations of gloss paint or left to carry their wear in smoothed-out hollows. They have been preserved by family ownership, a sense of maintaining what is still useful or sometimes just by chance, and now these places with unusual paint, crooked shelves, paper rollers, glass-fronted cupboards, and worn stairs have become beautiful.

Winifred McNulty, 2012

Gillespie's Pub, Mountcharles, Co. Donegal

Interview with Owen Gillespie

Mostly elderly men liked to come in to the pub and have a chat. Sometimes, of a fair day, a man would get a few drinks they weren't used to, but there was always someone to bring him home. There was a partition that slid back on a market day, the 22nd of the month. It was busy on a fair day; there were cattle all over the street. There was no traffic then.

Doors were never closed; there was no such thing. People would call in to visit. I remember once we were working inside, where we had a fitting room. The door was open and one of the cows came in and up the stairs, trying to climb out the window. When it charged out it took the hall stand with it.

There was no television, no radio and I remember the old men we served had a school of cards, twenty-five people betting 1*d* or 2*d*. Everything has changed for the better, but I miss the visiting houses.

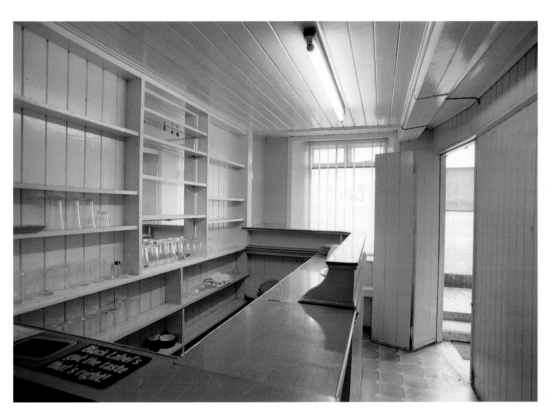

Gillespie's bar.

Gillespie Tailors, Mountcharles, Co. Donegal

Interview with Owen Gillespie

Tailoring at that time was an art. There were three tailor's shops in the village. One was in the house where Seamus McManus was born. Willie Griffin was the tailor there. He never missed Duffy's Circus when they came to Donegal Town. He travelled in on the railcar from Killybegs, laid on especially for the circus. Charlie Keeney and his sister took over after Willie.

On the opposite side of the street Jim Dawson and, later, Christy Doherty were tailors. Barney Gallagher was the tailor here. There were three dressmakers: Mrs Mc Loughlin, Mrs O'Boyle, who had three or four girls working for her, and Mrs Dunleavy. Material was bought in Magee's and everything was made to measure. Customers picked the material and the style they wanted.

We made ladies' and gents' suits. A suit cost £6 or £7. Every man always wore a suit collar and tie; you never went to a dance unless you were in a suit. I knew one man who had the same suit for twenty years. He'd wear it for special occasions and put it away carefully again. So many different people came in. We tailored for Major Lyons and for Seamus McManus the author. He liked a style with patch pockets and a belt: a tunic style. He'd come on holiday from May until the end of September. One of his favourite places was Inver Bay where he used to go with his first wife, the poet Ethna Carbery. They lived in Revlin House. We used to make suits for the local Gardaí and one of them, Garda Sarsfield, had his uniform picked out as the best in the county.

Every young lad became an apprentice to some trade; it was the accepted thing. I served my time as a tailor in 1942 with Barney Gallagher. My brother followed me in 1945. There were no such things as unions. We'd start at 9 a.m. and work till 9 p.m.

You had to serve seven years. You got half crown wages, 2s and 6d. I was fourteen when I started. You'd start by learning different stitches. When that was mastered you started making trousers. You had to get good at them before you got to jackets.

Tailoring took its toll on the eyesight. When we started there was a paraffin lamp hanging down with a low shade to put light on the work. It was fifty-candle power with a circular wick. We sat cross legged on a low

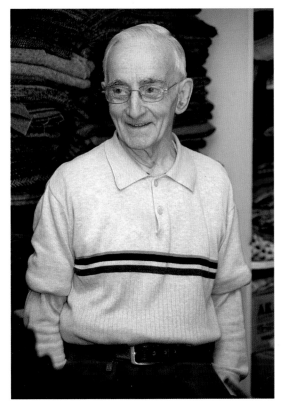

bench. We used two irons: 18lb and 22lb. There was a special stove where you heated them so in the summer time it was very hot. On Saturdays, John would be pressing the whole time to finish off. It was physically very hard work. There was a board for ironing sleeves that was known as the donkey. The iron was known as the goose.

Travelling tailors went around the country working for different tailors for the summer months. Winter was a slack time; spring was busy. If the travelling tailors had no work you gave them a shilling to keep them going: that was called 'the boot'. There was a character we had working who was on the road. He went to Ballyjamesduff to a tailor but got nothing. Looking back at the town as he left he said, 'it was no wonder Paddy Reilly didn't go back'.

You got to know all the tailors and you were glad to see them. They were mostly older men who were on the road the whole year. Before shops, the travelling tailors did the work in people's houses. They were kept and made the suit in the house.

In the late '70s we opened a tweed shop. Tony O'Malley, the photographer, came to do an article for Bord Fáilte as the shop was well known. He took pictures of our pantomime as well for the *Independent*.

Later on I worked as a cameraman. I filmed Derek Hill painting the cliffs on Tory Island and he told us how he was painting on the cliffs when an old fisherman came up and stood watching him.

'What do you think?' Derek Hill asked him.

'I could do better myself,' was the reply. When Derek Hill asked whether he had any paints the fisherman replied, 'I have three colours and a brush made from the hair of a donkey's mane.' That was the first time he met James Dixon the Tory painter.

In Mountcharles, every third building was a shop. Everyone was making a living. It was a great village with so many friends. We had a pantomime and two drama groups. We went to festivals in Bundoran and

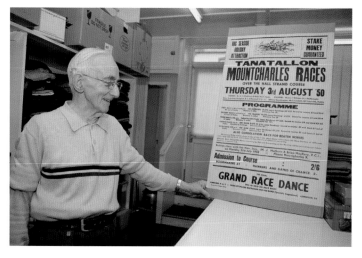

Last Day at the Races.

Sligo. When the visitors came, there were impromptu concerts in Brogan's Hall – 6*d* to get in.

We lived at the beach when we had free time – down at the small pier. On Sunday, everyone from the village was there. In the summer there were two race meetings when the tide was out. They had to pick a date with a low tide. We'd get a half day from school for the races. Three local horses ran in the Farmers' Race; they were working horses, driving bread vans. Horses would come from Belfast and Dundalk. They came by train; the committee paid their way. The prizes were small. The last race was in August 1950, insurance costs stopped it.

There were two tennis courts. Up in Glencoe there was a nine-hole golf links and a golf house on the farm. You can still see where the base was. It was a wooden structure; it was sold but the base is still there. You could still see the greens. Now there are cattle grazing the land.

Joe Walsh had a cinema. More than fifty people could be seated, and it was always packed.

In the 1950s a lot of people emigrated. There was no work. Eventually work could be got with the County Council and the ESB. Quite a few went to England, the others to the States. There were only two of us out of a class of eleven or twelve – Mary Dorrian and myself – who didn't emigrate.

It's a different place altogether now. There was no such thing as going into a pub; you went to a dance from 9 p.m. to 12 p.m. or on the big nights – the race dance – till 3 a.m. There were lots of visitors in the summer. Scottish people stayed in private houses.

We had a happy childhood. One word we never knew was boredom. We enjoyed every minute. We worked hard but we enjoyed every minute.

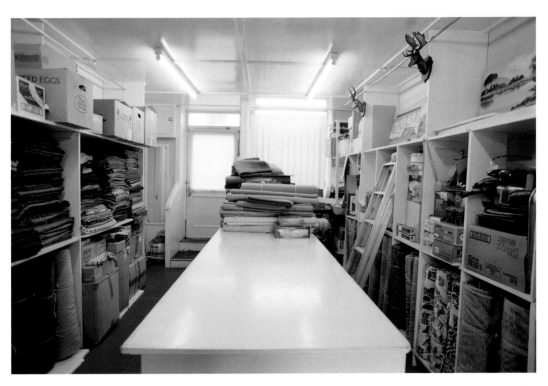

Interior, Gillespie's tailors.

Jack Davey's Shop, Ballintrillick, Co. Sligo

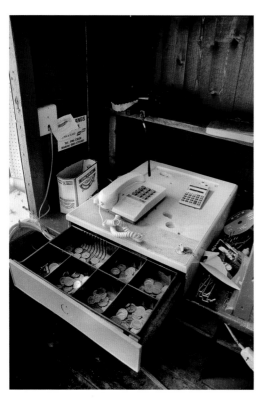

Davey's was a stout two-storey house on the last crossroads before the Gleniff Horseshoe. When you pushed open the half door, a clanking bell summoned Jack from the inner parts of the shop and drew him away from the rhythmical talk of farmers in the bare pub, or caused him just to lift his head. The movement of his hat signalled his position behind the chocolate stand next to the *Sligo Champion*. A greeting was followed by a small sigh as he stretched himself and moved into place behind the counter. Small, calm pieces of conversation led unobtrusively to the next topic. He never revealed much himself, but could sift talk carefully, as an archaeologist might, to find useful pieces and fit them together. If someone was away in hospital, or at their daughter's, he would have one less stop on his van rounds in the maze of roads around north Leitrim.

Sometimes there was a chance to look around the shop while Jack waited for further requests for bread, matches or cheese. As each item was added to the pile on the counter, he would leave a reverent pause and then ask gently, 'Is that all?'

Bacon slicer, Davey's shop.

I called one summer morning when the sun streamed into the shop, illuminating the mahogany shelves and picking up particles of dust in the slip stream of light between black wellingtons, columns of plastic buckets, Wellbecks thermal vests, and Milady stockings American tan 60 denier. The shelves held a symphony of hardware. Alongside the black shoelaces and shoe polish were rat traps waiting to be sprung, and Bachelors peas and beans stacked in pyramids. That morning, Jack was getting his flask and lunchbox ready for a day in the travelling shop. His brother Tom was already at the meat slicer; his cinnamon-coloured shop coat wrapped him like a parcel and somewhere in the back a sister was getting ready for a trip to Dublin.

Tom took my order for a half pound of ham. He closed torturous spikes over the side of ham and, with an air of serenity, pulled the chrome frame over and back until the rhythmic cutting echoed like a pendulum in the silence of the shop as each slice fell onto greaseproof paper. Then he lifted the paper at each end, balanced it on the scale, smiled slightly at the accuracy a lifetime of carving had given him, he looked at me, 'A half pound. Will that be all?'

Connolly's Pub, Sligo, Co. Sligo

Interview with Gerry Nicholson

Thomas Connolly bought this pub with his brother Dennis from their first cousin for £500. The brothers had been in America for years. There had been a pub here since 1780, opening onto Holborn Street. The Markievicz Road end was originally living quarters.

The pub was used by the dockers. Sligo had one of the biggest docks; five or six ships docked every day. It was a booming port, shipping timber, coal, and tea. People left this port and went to Glasgow and travelled to the great lakes of Michigan and Chicago.

Thomas was a town councillor. He was a Redmonite and became mayor in 1891. During the by-election in 1891, Parnell came to Sligo. It was at the height of the Kitty O'Shea scandal. Parnell wasn't welcome; men put sticks across the entrance to stop him entering Sligo Town Hall. Thomas Connolly lifted the sticks and Parnell signed the visitors' book, then Parnell was welcomed in this pub.

Thomas died in 1896 from TB. His daughter was one of the first women to qualify in pharmaceuticals in Trinity College, Dublin. Dennis took over the pub in 1896. His three nephews Jim, Tom, and Roger Fox worked here after school. At that time, the pub was licensed to sell wine, spirit and tobacco and it was a bar and grocery. We bottled our own Guinness and whiskey. There were up to fifteen people working here, bottling and packing tea and sugar, and a delivery boy. Horse and carts would be tied up in Holborn Street and if the owner consumed ten pints the horse knew the way home.

Jim and Tom Fox ran the pub and handed it over in the 1940s to their nephew, Gerry Nicholson, my father. My mother had to give up her job as a poultry inspector when she got married so she worked in the pub too.

The people from Forthill used to drink in the Holborn Street end and country people, especially from North Sligo where my father was from, drank in the Markievicz Road end. The last bus stop for the Bundoran bus was across the road. My father was a generous and shy man; he was well liked and was involved with Sligo Rovers and the Sligo Races. He always praised the loyalty of the North Sligo people

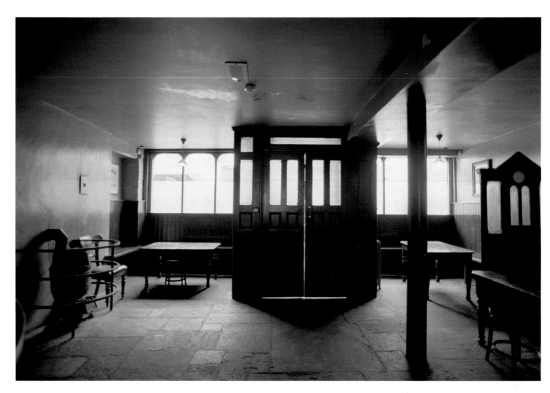

Holborn Street door, Connolly's pub.

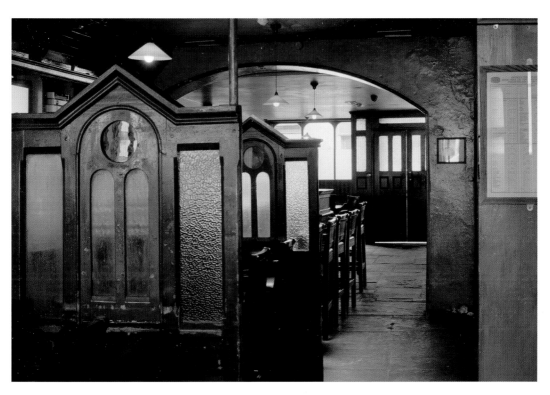

Interior, Connolly's pub.

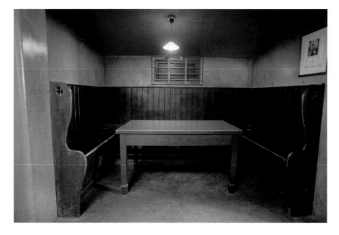

and, indeed, they came to honour him at his funeral in 1986. After his death, only a handful of people were coming in. Things were lonely then.

In the late 1980s, a whole new generation of young people started to come in and the pub became very popular again. Recently a good friend of mine, Frank Conway, who is a set designer, has helped in a careful restoration. He was reluctant to do anything, but there was wear and tear and leaks, essential maintenance. Frank was very sensitive and spent a good part of a year working to bring out the history of the place. He sourced fittings which blended with the originals.

This is the only pub in Sligo to have two entrances, and two pub fronts, one onto Holborn Street and one onto Markievicz Road. There was a fella in here one night who'd had too much and my father refused him. He wandered out around by the Ulster Bank and into the Holborn Street end. He walked up to the bar and my father turned round and said, 'I told you, you're not getting any more drink.' Yer man got a shock and asked, 'How many bucking pubs do you own?'

Another time, in the 1970s, before the new bridge was built, a soldier was being taken to Spike Island from Finner Camp. The soldier knew Sligo and asked to answer a call of nature in the pub. Not wanting to embarrass him with handcuffs, they let him in on his own. 'I'll be out in five minutes,' he told them. He ran through the pub and out the Holborn Street door. He was missing for three days.

Of the future? We don't know what the future holds, let the next generation decide. It's a different time now.

Travelling Barber, Co. Donegal

Interview with Barber Eamonn Friel

I trained in Townhead, Glasgow. I was indentured, sold into slavery. My father took me up and signed the forms. It had cost him £100 for my brother to train. I was taken on for nothing. I started at 10s a week; that covered my train fare from Clydebank. We worked on tips. In the first year you'd sweep the floor and take coats. It was very formal: for the first year you didn't get near a scissors, you stood and watched the boss.

In the second year you'd start a haircut with the machine and the boss would finish it off with the scissors. I went to college for a City and Guild's training that lasted three years. We learnt how to shave the different cuts: club cut, slither and razor cut, and Turkish head massage and face massage.

The traditional shave has died out a lot. I don't do it as I don't carry water. With the new razors you couldn't get much closer unless you were pulling the skin off the guy. In college we had to learn to maintain the machines; how to strip them down and build them up again.

I wouldn't cut my wife's or my daughters' hair. I had two women came in one day and they had a wee jar on them.

'Will you cut the hair?' When I said that I wouldn't, they accused me of being a male chauvinist pig. I said, 'I may be, but I'm not cutting your hair.'

When I started in the 1960s, it was a bad patch. Everyone grew the hair long. Later on, they started to tidy it, but the traditional barber wasn't trained to cut long hair, so men went to the ladies hairdresser, later fathers brought their sons too.

When short hair came back in, the ladies hairdressers were more used to doing a club cut but barbers cut with a comb and men started to come back to the barbers. People sometimes say you've the best job in Ireland, with the recession, because people will always need a haircut, but I say, the undertakers are better than me; when he calls to your door you can't tell him to call back next week.

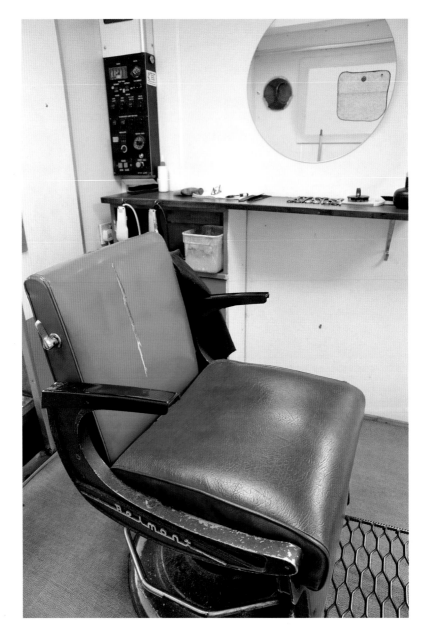

Barber's chair, travelling barber.

I noticed there were no barber shops in these small towns. I thought it'd be handy to have a room in each, then I saw a mobile bank and I thought, 'That's more like it!' After a few years, I started on the road with a mobile. I got the chair from Hughie Friel, a barber on the Port Road in Letterkenny. I went in to buy one off him and he gave it to me for nothing.

I started going around the towns: Glenties, Dungloe, Gweedore, Falcarragh, Milford, Ramelton and Rathmullen. I only work four days and can stay overnight in Dungloe with relatives. It's a very social place and being mobile you get to hear news from all over the county.

Of course there's a lot of chat, when you talk you solve your problems. Small talk is very important. To me that's my job: to keep the conversation going, throw out the line, you're fishing, and someone else will take it up. Sometimes now you'll go into a pub and there's a young fella there, they'll serve you but they don't chat. When you get chat going in a pub, even if they are only telling lies, you come out saying, 'I've not had such a bad day'. It's better than a psychiatrist.

The barber used to have a red, white, and blue pole outside the door: red for the blood, white for the bandages, and blue for the arteries. The urban legend is that barbers used to do amputations and when they started to get good at it they wanted to be called 'Doctors'. They weren't allowed to so they called themselves 'Mister'. Later on, when doctors asked the barbers to join with them, they wouldn't call themselves 'Doctor' and that's why surgeons are called 'Mister'.

At one time, you didn't cut your hair during Lent. In Ireland you didn't burn hair; it was put into the stone ditches. Years ago hair came from the nuns for wigs. We learnt how to make wigs when I was in college. At that time the hair came from Asia. You had to tease the hair out and find the resistance which is at the root, then you wove it onto a mesh on a block, then you trimmed it.

Men don't wear wigs so much now. People are less self conscious. Men don't usually dye their hair, our validity comes from within.

The barbering is a good trade; it's a trade that's easy carried. If you ended up in Timbuktu, someone would want a haircut. When I was young, I wanted to work in the shipyards in Clydebank; I wanted to be a welder. But my mother said, 'You're going to be a barber', and in those days you did what your mother said. She could see far ahead.

Everybody has good and bad days, even if you got a job testing mattresses you'd get fed up of it.

Grocer's Shop, Co. Monaghan

My grandfather, Robert Leary, started the shop. He went to Canada, came home, and bought this place in the 1890s. Some people say it was a pub, but I never heard that in the family; I don't know how true it was. He got married and reared a family of four here. My mother was the only girl. She stayed around, got married and she had four children: three girls and a boy.

My grandfather sold meal, cattle feed, and coal. Food was all loose: tea and sugar had to be weighed. It created a lot of extra work for the family. We sold biscuits loose; they were in boxes and people bought them by quarter, half or pound weight, according to their wants. In the drawers we kept cereals of all sorts: rice and tapioca, all loose, all to be weighed.

Saturday was a busy day here, as there were deliveries to be made by horse and cart; it was the only means of transport. At Christmas you bought all the stuff for baking: sultanas and currants and all had to be weighed out. There were boxes of chocolates and different cakes. There wasn't as much fuss about Christmas as there is now.

The shop is just the same as it always was. There have been no changes; the adverts are up as long as I remember. The house used to be thatched, but that was changed long ago.

Gradually things got quieter – these days everyone goes to the supermarket. There's a bigger variety and it's cheaper; you can't blame them. Older people do their shopping here, but as the older people depart, there is no one to take their place.

I wouldn't want to retire; it's good to keep working. When you grew up here, you know everybody. That makes a big difference.

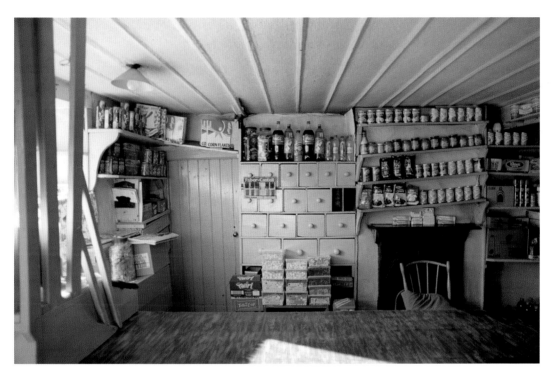

Behind the counter.

Shoe Shop,
Raphoe, Co. Donegal

Interview with Mary McGranahan

It was always a shoe shop, going back years. Shoes were made here and the bench they were made on is still here. Jane White owned it. She married a Mr Sheldon who was a TD. They were from St Johnston. Patsy bought the shop in 1970.

I used to work for the AIB. I came here and didn't know anyone. I was from West Limerick, between Rathkeele and Newcastle West. In those years there were no jobs; you had to have a connection with the bank, a bank nominee, to get in. My uncle was a solicitor for a local bank so that's how I got in. The children of bankers had special places kept for them; I saw a lot of people working there who weren't suited to banking at all.

I was working in the shoe shop by accident. The girl who worked here went to work for her brother in Kee's Shoe Shop in Stranorlar, so I started here. I would've preferred clothes; I'd have liked a shop like Louis Copeland.

The people coming in and out were fabulous; 99 per cent of people are terrific. I don't miss it too much as I live in the town. I never wanted to change the shop, it suited people the way it was. Modernisation and change is not always the thing. The shop is full of psychology. They had more psychology than people with PhDs. People had a natural wisdom.

I gave out stuff on 'appro', approval. Someone would ask me to send a few pairs of shoes home for them to try and they always came back, you might sell an extra pair, but you couldn't compete with the prices of shoes in the big stores.

I would've changed nothing. I couldn't change it; it was the way it was.

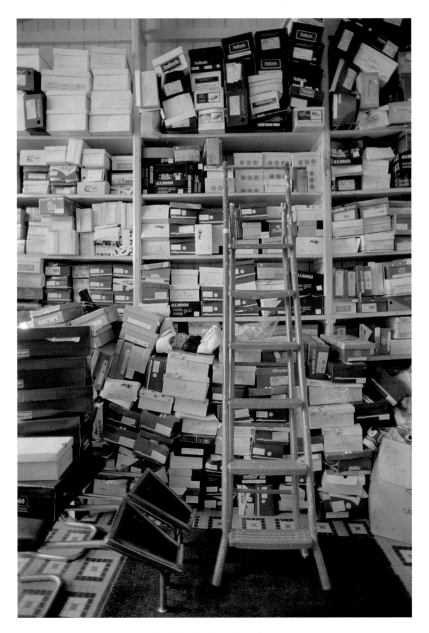

Interior, Raphoe shoe shop.

Gambles,
Ramelton, Co. Donegal

Interview with Andrew Gamble and Betty Davison

Andrew: Let it be fact or fiction, the counter was once the dining room table of the landlord, Sir James Anglesey Stewart of Fort Stewart, the grandfather of the current landlord Alan Stewart, the boatbuilder. I was there once and it is a very large dining room.

My great-grandfather, Andrew Gamble, started the business between 1880 and 1885. He was from Cranford. There were five brothers in the family: some went to America – one went to the Californian Gold Rush but he didn't get any gold. He came back, started a school in California and took my grandfather, Daniel, out to be educated by him. When my great-grandfather died, Daniel Gamble came back from the States to run the place. He went to do a tailor and cutter course in Drury Lane, London. He came back here three years before the end of the century in 1897.

At one time, there were thirteen tailors; it was the main shop in the county. They used to supply goods to Tory Island: big hampers went from Magheroarty out to the island. When people came from Tory, or any long distance, my granny used to bring them into a little dining room for tea and scones. My mother and father took over when my grandfather died in 1946. According to my mother, it was my grandmother who was the real business woman; she was strict in the shop.

There's not one bit changed in the shop since 1932, only the cash office upstairs and the pulley you sent money up in has gone. Underneath the stairs was a wee knot hole. When you got shady customers my grandfather stood in there and kept an eye on them.

I remember two girls working upstairs in ladies' fashions, and a fella down here. We had light hardware, shoes and boots. It was a lot busier. There was a big oil heater in the middle of the shop and farmers used to gather 'round it to talk on a Saturday night, after they'd done their shopping or business in the town. We didn't close till midnight some Saturdays, especially if it was cold.

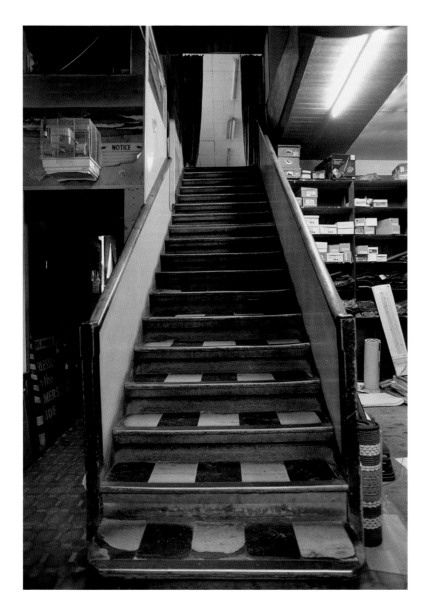

Interior, Gambles.

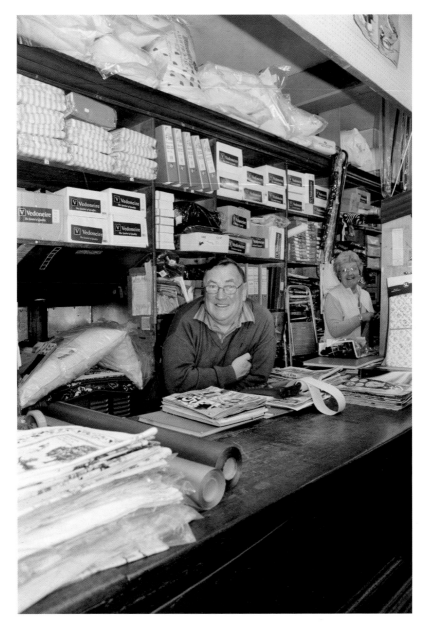

Andrew Gamble and Betty Davison at the counter.

It was the biggest shop in Ramelton, comparative to Magee's in Donegal Town. There was a separate place for tailors and a four-storey building behind. On the top two storeys, my grandfather did his cutting. After he died, people chose from samples and their measurements were sent to Dublin where suits were made up.

My father worked in the shop until 1952. There used to be a voluntary fire brigade in the town and he was in charge of it. While attending a fire at Cassidy's, where Whoriskey's is now, a wall fell on him and he was paralyzed, and from then on he was in a wheelchair.

I intended not to be here at all, I wanted to go to Australia, but I had to stay in the shop. I had a brother in the bank, a sister died when she was three, and my mother had twins who died soon after birth – that was not uncommon then. So I started in 1948. I was a reluctant shopkeeper; I would've preferred to be out on the boat.

In the 1950s we gave up footwear. There wasn't the population for doing all sizes and shapes. We started doing carpets and they're still going.

Years ago there were a lot of bakeries in Ramelton. They discovered the ovens when they were building in the 1950s. None of them were going in my time. There were nine pubs in the town and eighteen small grocery shops. In those days, you knew everyone from two years old to a hundred. The population had been about 1,500 or 1,600. It dropped to seven or eight hundred and it's now on the increase again. In the town there were dances, badminton clubs, tennis, and terrific football. We had a small cinema going in the Guild Hall. Gambles owned it. There'd be concerts too, all local talent.

Betty: I came in at fourteen, after I did my leaving and I'm sixty-one now. Andrew's mother suggested a job to my mother. It was the month of September. I enjoyed it in the earlier years; people weren't as fussy. Now there's too much variety. People go to Letterkenny. We cater for the elderly. The carpets and floor coverings were the best. We wouldn't have been able to carry on with just the drapery. It was a way of life. I've had a good boss, good if you don't want a big wage.

Andrew: In the wages book here I started in 1948 on 7*s* 6*d*. In 1939 tailors had £1 17*s*, by 1957 my wages were £2.

Betty: I started on 9 September 1961. I think it was a pound I got.

Andrew: Oh I gave you too much! People didn't seem to need so much money in those days.

Betty: You enjoyed people coming in. I don't know people anymore, there was a time I knew everyone, not anymore. Ethel Montgomery was here when I came at first. I used to go out home with her on the bicycle. Her mother would have brown bread and the table set. Ethel left in 1962 and then we were on our own. Andrew enjoys people; often when visitors come looking to trace relations, the historical society send them up here. They get more information from him.

Andrew: During the war we got into turf and coal. We'd go out on the lorry – I enjoyed that – and buy turf. Some people took money, some took corn or straw. There was always a bit of barter going on. I used to enjoy going to Bloody Foreland. As soon as you landed you'd be brought in for two eggs before you started. There were no guards holding you up.

I remember once when we had the Undertakers. We had arranged to go with the local guard for turf to Glenveigh, but my Father had to take an order for a coffin. He landed down with the guard, 'Take him with you' he said pointing at me. I was twelve years old and I drove the guard out for turf in the lorry. It was a good job there wasn't much traffic on the roads then.

Hanna Hats,
Donegal Town, Co. Donegal

Interview with John Hanna

My father, David Hanna, started the business in 1924. He came from Belfast. He always had a great interest in clothes. He worked for a company called Clarke's in the Lower Falls. He got a job there when he was eighteen or nineteen. For these four or five years, he was sitting beside old men of eighty-five to ninety years, in the place called 'The ship that never sails', where old tailors sit with everything around them. Dad was proud to be working there, but he thought, 'If I stay here, I'll be like these old gentlemen', so he got himself a job as a travelling salesman, cycling from Belfast to Derry to sell brushes on a bike.

This great calling was always with him. He read an article in the *Belfast Telegraph* for an apprentice tailor in Donegal, so he cycled from Belfast at 5 a.m. and arrived here at midday for his interview. He got the job, himself and his bike never left since. He was working with a family tailor, Mick Mc Daid. After two years the tailor died. Dad didn't know what to do as it took seven years to qualify. Mrs Mc Daid said, 'David you can stay on and work here.' He wrote to *The Tailor and Cutter* in London and got two manuals, 'Measure, cut and make a suit of clothes', and from that on he became a bespoke tailor.

He met a woman called Margaret Glacken from a noted house, the 'Lough House', the far side of Barnes Gap. It was a halfway house for travellers. There'd be sixty or seventy bicycles outside belonging to people coming for a hooley. When people were tramping geese from Sligo to Derry, they would stay in the Lough House and the geese would graze overnight. As the geese left the meadow, they had to walk through a mixture of gravel and sand with something sticky added to stop them flying, and they headed off to Derry.

Mam was nineteen and dad was twenty-seven when they married in 1932 after a courtship lasting two years. They took the train to Dublin from Donegal, and went to Croke Park. It was the year of the Eucharistic Congress and Count John McCormack sang in Croke Park. They had eleven children: seven girls and four boys, and fifty-six grandchildren.

Templates, Hanna Hats.

Dad loved tailoring. In the 1960s, classical French and Italian suits were being made off the peg and that started the demise of the bespoke tailor. The bespoke suit had hand-made button holes and hand-sewn lapels.

In 1961, all my sisters and brothers worked for him and my father was wondering how he could keep his brood together. We were brought up beside the McEnhill's. Castle Street was our playground. Evelyn McEnhill married a Dublin man: Paddy Kane. They went to live in America in the early '60s. When Paddy came home, he went to visit my father in the wee tin hut in Tyrconnell Street. Dad admired his hat; it was from the Orvis Company in Manchester, Vermont. Dad looked at the hat and started to make one like it. He made a hat and sent it to the Orvis Company and in 1969 he got an order from them. We still supply the company today. The tin hut was demolished and a factory built in 1974. Where the factory is now was once an orchard with gooseberries and plums. We used to steal apples from our own father.

We used to sell to the Irish Pavilion in Manhattan. In 1972, Daniel Patrick Moynihan went to JFK Airport to collect the German Ambassador and brought him to

Original hat blocker, Hanna Hats.

the Irish Pavilion. The ambassador picked out his hat. They were kept in creels. He had to search for the size and colour he wanted. Then he was taken up for an Irish stew. He took off his hat and Daniel Patrick Moynihan said to him, 'Never turn your back on your hat because it's the Irish walking hat, if you turn around it'll be gone.' So since then it's been known as the walking hat. In the New York Times there was a picture of fifteen senators all wearing the hats and the picture was called 'The Walking Senators'. That hat was the one that took the business through to today.

In the business, we have twenty-three people working. We give a service like no one else; when we have an order we can get it out the following day. My brothers: Patrick, Edward, and John have input in decision making. We make all types of hat; each of them has a story and reflects something of the natural

landscape around Donegal. The 'Barnesmore' resembles the beauty of the hills, the colours of heather. The 'Walking Hat' is a popular fishing hat; you could bail out your boat with it. It's indestructible. There's the 'Vintage Cap', with a leather trim, the 'Lug Cap' to keep the ears warm, or the 'Newsboy' an eight-piece cap. We have pictures of Pavarotti wearing his. We work together on a new concept, working with Tony our cutter, trying it out see how it looks. Often the creation of a new style comes from a mistake.

Terry O'Sullivan, the journalist, did an article on dad. When it was over dad said, 'It's time for me to go for a swim.' As he was throwing his leg over the bike, Terry asked him, 'How long do you think these hats will last?' dad replied, 'As long as people have heads.'

For me it all depends on what you want out of life. I want to remain here. I love Lough Eske, I love my friends and social life. I have a 70ft punt out in Lough Eske to fish: it's brilliant.

Regarding the business: to stay ahead we have to be creative and motivated. We have to watch what's happening and be adventurous. Never be afraid to make a mistake. Never be afraid to take chances.

Oatfield Sweet Factory
Letterkenny, Co. Donegal

Interview with Desmond Doherty

Ira James McKinney and his brother Haddon McKinney were the men who started Oatfield. They were very honorable, decent men who were very energetic. They had started buying sweets wholesale from Russell in Strabane. One day, they went to pick up supplies from Russell. He said he was selling too cheap and attempted to double the price, so they decided to start making sweets themselves.

On 15 August 1927, in the backyard of the shop premises, they made their first sweets in an open copper pan, making pineapple-flavour sweets. In 1929, they bought the field and in 1930 opened the first factory employing six people. Mayfield was the name they started trading under, but there was an English company with the same name. Someone said why not use, 'Oatfield' because the field where the factory was built was called Oatfield.

Sweets were rather simple in those days: they were mainly boiled sweets and toffees. They were sold loose and came in glass jars or tin cans. The shopkeeper weighed them out; a quarter of sweets was the usual order.

In 1932, De Valera came to power. He was trying to promote Irish industry and he applied huge tariffs on imported goods. This led to the Economic War, but every cloud has a silver lining. A 'packaging tax' of one penny was applied to each pack of imported sweets. A single wrapped sweet was considered a pack!

That prompted some of the big British companies to establish a base in Dublin. It was also the first time some of these companies had cooperated in business. Cadbury and Fry's joined forces and built a factory together as did Rowntree's and Mackintosh's.

The Second World War started eight years after the factory opened. You had rationing of raw materials. There was a quota system based on previous usage. The McKinney's had reinvested their money back into the business and had a substantial usage, so they got a good quota although it was not enough and they had to ration sweets to customers.

After the war the business started to expand. The early 1960s was a more competitive era. I remember a huge debate about the cost of sweets. At that time they were sold at six old pence a quarter – that was a single coin. To move away from that price meant another coin.

The boiled sweet was the common product and the easiest sweet to manufacture. Oatfield invested heavily in capital equipment. The new technology could pump chocolate, toffee or jam into the centre of a boiled sweet. This resulted in very different sweets and textures.

Another significant decision they made was to invest in equipment to pack sweets in 'roll pack form'. There were very few companies doing that and it was very successful. Then they started doing pre-packed bags manually, the sweets dropped into separate bags: it was slow work.

I was appointed to the office in 1963. I did general admin jobs, and sales and production analysis and presented them to the McKinneys every month. Doing production analysis I could see the sales of pre-packs were growing. Being young and foolish, I made a prediction that that's the way things would go and I told the Mc Kinneys at a meeting. But the prediction was right. They purchased a bagging machine and that gave Oatfield a huge advantage over competitors, so much so that Oatfield captured 25 per cent of the retail bag market. Shopkeepers changed unbelievably fast from weigh out to pre-pack. It was very easy to reach and sell.

Through the 1970s and '80s, exporting expanded and the company invested in a lot of equipment. There were four of us working full-time on export: putting in one export order a day. That involved a lot of logistical work on transportation, custom documentation, bank documentation and so forth.

Oatfield sold 10 per cent of its produce in the Arab world until 1990: to Saudi Arabia, Kuwait, Bahrain, Dubai, Oman, Jordan, and Palestine. It was interrupted by the Iraq invasion of Kuwait in 1991. We had a container on the high seas going to Kuwait and it had to put in at Dubai. Kuwait was a great trading post, with traders came from Iraq, Iran and Afghanistan.

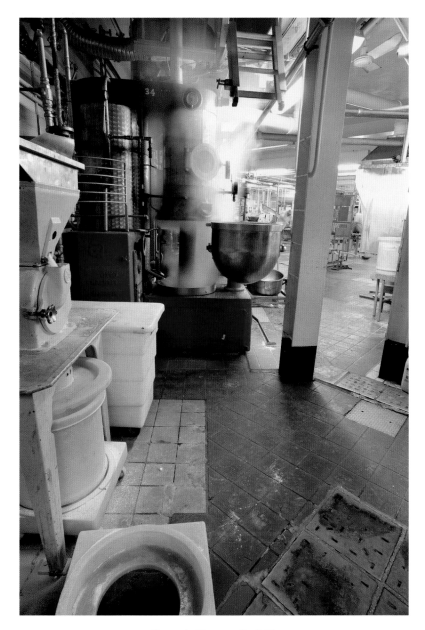

Copper boiling pan, Oatfield.

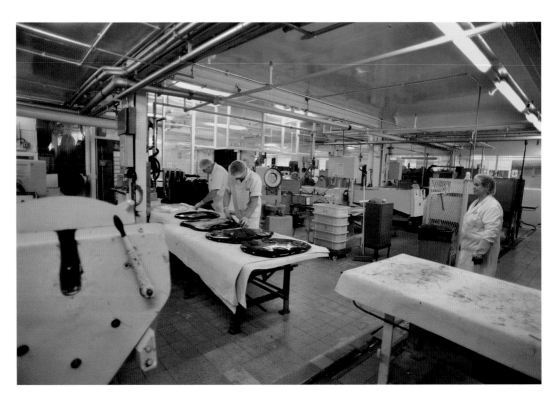

Production Room, Oatfield.

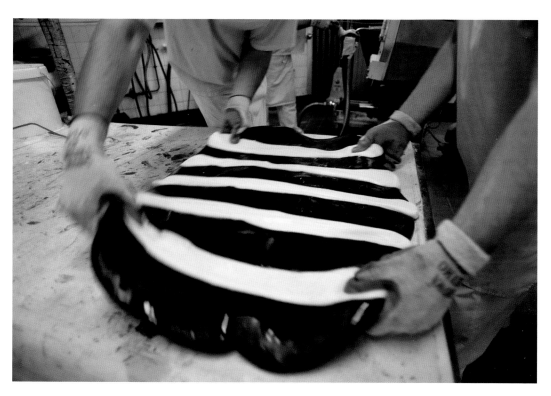

Putting in the stripe, Oatfield.

Sugar String.

We also supplied to Singapore, Hong Kong, New Zealand and Australia, Pacific Islands, Tonga, Fiji, Tahiti, and Papua New Guinea as well as Libya, Tunisia, Morocco. I also travelled to Canada, Chicago and New York and the Caribbean. I got to travel a lot and you learned how people lived.

One of the founders, Haddon, died in 1972 but the McKinneys retained control until 1999. Ira McKinney lived until 2000 although control had already passed to the second generation.

In 1999, Oatfield was sold to Donegal Creameries, but when there was a change of Chief Executive in 2005, the new CEO decided the sweet factory was not core business and it was sold to Zed Candy the current owners.

At its peak Oatfield was producing 90 tons of sweets a week. There was a lot of activity and it had a huge positive impact on Letterkenny.

It was a good company to work for. There was a loyal core of workers who had a pride in what they did and they did their job well.

Liquorice Bonbon.

Iniskeel Co-Operative
Agricultural Society, Co. Donegal

Interview with Paddy McMonagle

This was the first co-op in the area. It was registered on the 12 September 1908. People bought shares and set it up; it was owned by the people. When it first started it was in the wee shed with the corrugated roof where I keep the gas. Every customer had a passbook and a folio number. At the end of the year they were paid a dividend.

You'd get so much for every pound you spent, so you might get twenty pounds back, maybe more. In the passbook, all purchases were put down and it was noted what was paid for and what was credit. Everything was settled at the end of the year. The dividend would help pay it off. When I came here the dividend was on the way out and it stopped in the 1970s.

People used to live within their means: they grew their own vegetables, potatoes, their own corn, and had their own milk and eggs. They'd buy tea, sugar, flour in ten-stone bags. People sold their own eggs or bartered for goods, one time the wee shed was the egg store. The shop was renovated in the late 1980. In the old shop, you had a wooden counter going all the way round. You had parcel paper hung up and cord for tying parcels. There were no boxes or plastic bags. Down there was a side of bacon hung up for slicing.

There is still a travelling shop, although the days of the travelling shop are nearly gone. I liked it; you'd go out with a big load in the morning and it might be six or seven before you'd get back. Them days, the roads were bad with heavy loads and vans not as good. You'd wreck two or three springs a week. They were great shoppers; there'd be certain houses where I'd get tea and I still do. There are huge differences now.

Member's book.

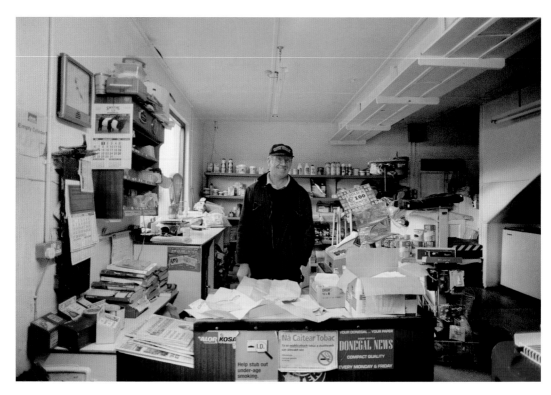

Paddy McMonagle.

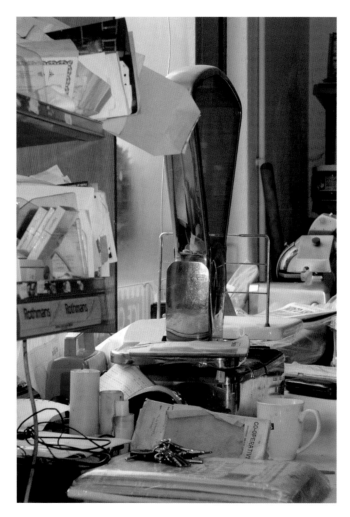

Interior, Inishkeel Co-op.

It's nearly completely gone compared to them times. I remember going round townlands where there were four or five households, Cloghernagore, Meenatawey, Crocam. Now there's no one in them.

The young won't come to the travelling shop. It has to be the towns. It's the same with the publican: one time they'd have their own customers, now it's different a gang of young lads that might call in for a drink and then go away to the town.

We keep the wheels turning here. Summertime is a quiet time but winter is busy with animal feeds, coal and gas. In the 1970s, a refill of gas was 19s 9d. Today it is €30, but I suppose the €30 is easier got now than the 19s was then. I would be worried about the future of the young people if the times get hard. I save my own fuel for the fire but young people nowadays are not in the same boat as me. I worked in Glasgow in 1967 and came back working for a contractor for several years. I started here on 26 January 1970. There've been tough times and good times and sad times, you get that in life, that's the way it is for everyone.

Moffat's Shop,
Raphoe, Co. Donegal

Interview with Sydney and Marie Witherow

The chair you are sitting on was made in Czechoslovakia and cost 8s 6d. It must be here since 1924. In 1922, the shop was burned during the Civil War. It was rebuilt for around £4,000, ready to walk into. I have the plans still and all the specifications. It was built by a man named McClay who was married to one of the Moffat family. He built the cathedral in Letterkenny.

John Moffat never married. He died in 1971 and I took it over then. I had been his partner. I've been working here for fifty-one years. I started at fourteen years. When I joined there was a man who had been in the shop for fifty years. I never thought I'd be here that long.

We did up the shop in 1973. It had been much more old fashioned, with boards on the floor and the counter running the whole way up on each side and the stairs in the centre. We opened up the living area. There was an office with a tall desk with a sloping top and a tall stool. The invoices were hung in clips on nails all around the walls. Menswear was upstairs and beds were up on the third floor. They had to be carried all the way up, and all the way down when were bought. Upstairs there were carpets on polished floors. Downstairs there were bolts of fabric for suiting up to the roof. There was a tailor in Raphoe and two in Convoy who would make up the suits. Ready-made suits were around when I came in the 1950s and they took over eventually.

The fair days were busy; there were four fair days in the year, the main one in June. That's when the shop was burned in 1922, on a fair day. The family escaped over the wall in their bare feet. Only one thing was rescued by a passer-by: buffalo horns. They'd been sent by Willie Moffat who worked on the Northern Frontier as a surveyor. The buffalo horns were the only thing the family didn't like and they were the only thing saved.

Models, Moffat's.

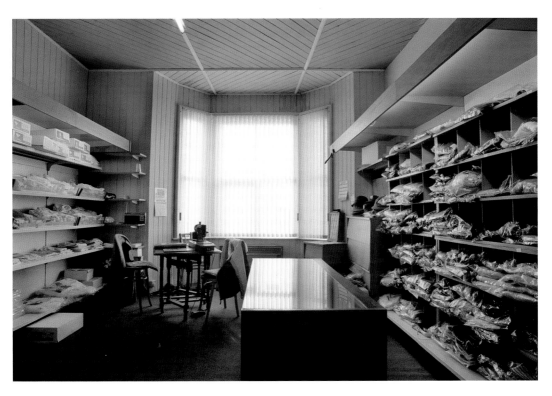

Sewing corner, Moffat's.

Quigley's Grocery and Bar, Collooney, Co. Sligo

Interview with Alphie Quigley

My father opened the shop on the day of the Carricknagart Horse fair, 1 February 1930. My father came from Ballinacarrow. He had served his time in Mullvagh's in Ballisodare. For small money he headed north to Belfast. He purchased his own business in Belfast; there was plenty of life to him. He came back here then and bought the shop in the late 1920s.

I started to work here after I finished school around 1957. I had boarded in Summerhill for three years. The shop was my life. We did all our own bottling. It was all delivered in wooden barrels and that was my job in the evening when I came from school, from the age of twelve. There were four siphons to fill four bottles. To start them you had to give them a suck. We bottled Guinness and whiskey; a 5-gallon keg of whiskey filled thirty five-naggin bottles. It was corked with a corking machine and then we put on the White Power's label. That time there was more of a sale for bottled Guinness than draught, although we did that too. We stopped bottling in the late 1960s.

The bar was busier than the shop. There weren't too many supermarkets, none of the Dunnes Stores: it was a different scene. We packed our own tea and sugar. There's the old coffee grinder; we'd get the beans and grind it up like Nescafe. Everything was delivered from Sligo wholesalers, Blackwood's. Biscuits came from Jacob's in tins, all loose. We had a big glass case with a lid that held ten tins in two tiers. There were no packets then.

I've had a happy life: plenty of work from 10 in the morning until 10 at night. You didn't get much time for sitting. It's all different now, the shop is more of a convenience now. Years ago we did more, we used to do cattle feed and feed for hens. We're in the petrol business since the 1950s. There was a big volume of petrol. It used to be 'Mex' from McMullin brothers in Dublin, then Maxol. It was the seventies before the volume of cars increased.

I wouldn't like to retire. I always think about a traveller who used to call here and I used to say to him, 'Are you thinking of retiring?' He used to say, 'If you rest you rust, if you rust you bust.'

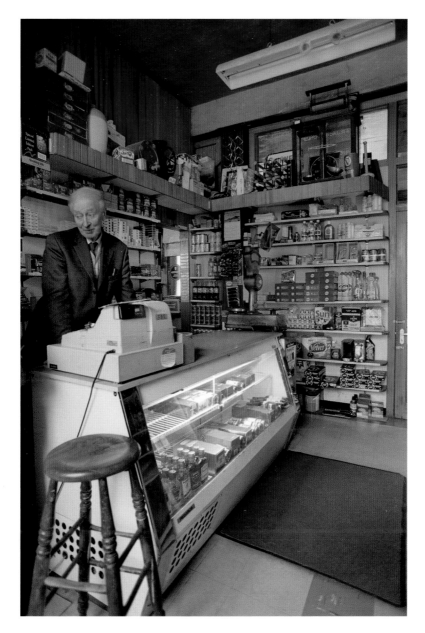

Alphie Quigley.

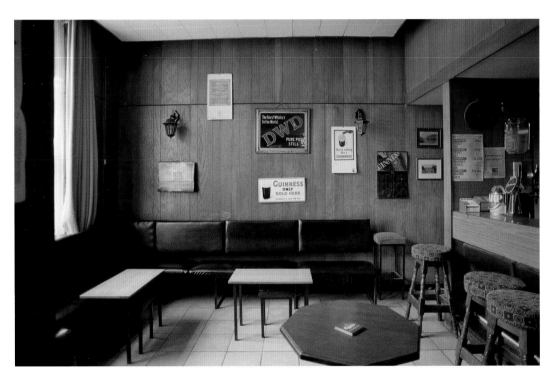

Lounge, Quigley's.

McDaid's Minerals, Ramelton, Co. Donegal

Interview with Mr Edward McDaid

My grandfather, James McDaid, moved in from farming on the Loughside and bought a shop and house. He started a barter system with the farmers he knew, exchanging tea, flour, sugar for spuds, eggs, chickens and turkeys. The eldest of nine children, he had an idea he would make it without inheriting land. He was an entrepreneur and good commercially but not so good on the land, although he always had a hankering after farming and bought several farms later on.

My uncle had a pub and knew what products were needed in the licensing trade: that was how the wholesale side of the business developed. My father Jim and all my uncles were involved with the firm.

Football Special has been going for about fifty years. It came about because in the 'off season' every soft drinks company sits around thinking 'What can we do next?', experimenting with flavours to create a unique drink. One of my uncles, Eamonn, was trained by McKinney & McGinley Minerals in Belfast. He trained in the 'syrup room' where all the mixing is done. It's the kitchen, the lab, the quality control of a soft drinks factory. Luckily he was disciplined enough to measure specific ingredients and the sequence they were added so that a taste could be replicated.

They played around with different ingredients but the basic raw material is water. We have our own stable spring-water source. It's the same composition all the time. It's pumped out of the ground and filtered to an insulated tank which keeps the temperature cool. It's important to have a lower temperature so that when you add CO_2 gas there is more saturation of gas and you get a better 'mouth feel'.

Football Special was used in football clubs when a cup was being presented and it was put into the cup instead of whiskey for those who didn't drink. It was first called Football Cup, and then Football Special. There was much more life to it than orange. I think of it as a layered soft drink. There are seven different fruit ingredients. Taste is very powerful for evoking memory. People say the taste of Football Special transports them to another time, to summertime on country roads, to gardens where they played with friends, to a time when everything was safe.

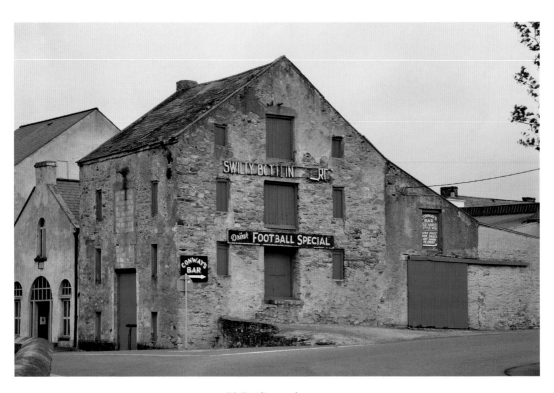

McDaid's storehouse.

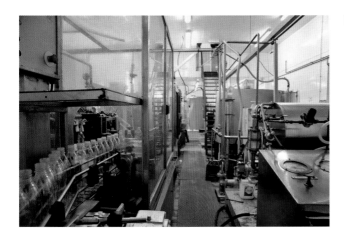

Bottling line, McDaid's.

What distinguishes us as a soft drinks company is that we're the blenders of ingredients. We deal with all the major 'flavour houses'. For example, for our Banana Cream Soda we go to Naarden, which is a Dutch company. They are Dutch traders who own their own banana plantation. We buy from them because the quality of their banana essence is very high. We buy from two or three flavour houses and blend them so that we get a unique mix, a mix you wouldn't think of. We retain the recipe for the mix. In that way we have kept the syruo room and the ability to develop and change our processes and our products.

There are companies who are contract bottlers for Coke. A magic mix will come and the bottler adds very specific amounts of sugar and water with stringent mineral standard. Coke controls the mix, and the bottling company just finishes the product in the same way we used to finish Guinness. Cooney's in

Tipperary and Britvic Club Orange still have control over their products, but as companies get bigger and bigger there's a temptation to consolidate. The opportunity to develop new drinks is shifting to the control of the big companies, partly because the capital investment to stay ahead of the posse is huge.

Family businesses are like the mafia: you can never escape. I didn't know you got holidays until I worked for other people; Christmas or Summer school holidays it was straight onto a truck or a bottling line. Myself and my wife, who is from Ramelton, worked in Dublin and London, but I always wanted to come back to Donegal. I'm not a city person, so I returned and took over the business.

We're a small company, employing half a dozen people. We've good prospects for growth. Our product range includes Ice Cream Soda, Exotic Pineapple, Smooth Banana and Football Special.

Three years ago we closed our wholesaling business in Letterkenny. I had to make a choice about Football Special. I could have given up, but I believe in being independent and I have a love for the business.

For the future we have a goal to make Football Special Ireland's national soft drink.

Johnston's Shop, Blacklion, Co. Cavan

Interview with Harold Johnston

The shop started in 1901 with my grandfather and grandmother. My grandmother was a dressmaker. She was from Blacklion. She had five dressmakers upstairs who used to make everything. In the twenties, after the war, there was more manufacturing and the dressmakers found other jobs.

Before the twenties, all the goods came from Belfast by train. The commercial travellers at that time would come twice a year. Some of them drew samples with a horse and cart from Belcoo station. They'd spend half a day here and then go back to Manorhamilton on the Sligo and Northern Counties Railway. The Sligo Belfast train ran via Enniskillen on the Great Northern Line. Coal and everything came into Belcoo station; there were a lot of people employed in bringing goods from the railway station. Once the 'Belfast Boycott' started in the twenties, goods had to come from Dublin to support industries this side and a lot of suppliers set up

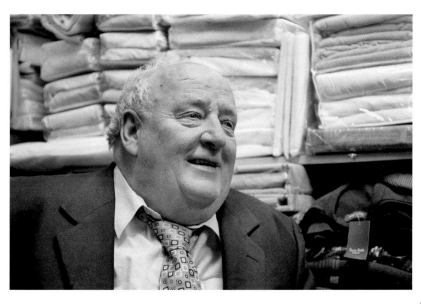

Harold Johnston.

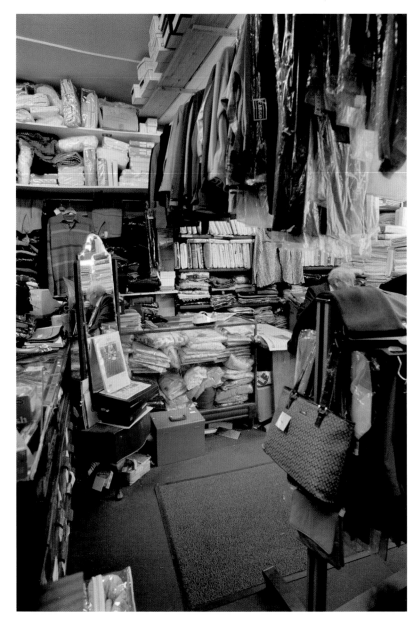

Interior, Johnston's Drapery.

Drawers, Johnston's Drapery.

branches in Dublin. People used to go to Enniskillen to buy things. They arrived this day and there was a customs man on the road. He turned them all back and that was the end of the open border.

Grandfather died in the 1920s. My father went into menswear and shoes. He had a job travelling for Callaghan's of Limerick: they made different types of leather for shoes. In every town, there were four or five shoemakers repairing leather soles. He was lucky to get that job. He worked the whole of Donegal, Sligo, Leitrim, Louth, and Monaghan, He had an Austin 7 and then several Fords. In Donegal, they would take the leather up the west coast in fishing boats to save the road transport.

All changed in Blacklion in September 1939. There was a circus in Northern Ireland. Because they had German performers, they had to get out or they would've been interned. The nearest border was Blacklion. The customs wouldn't let them through so they set up in a field at the back of the village. The customs came from Sligo to take an inventory of everything they had, lions and all. Then they travelled on through the Republic. During the war, one of the sea planes from the Lough Erne Base landed out in Lough McNean. It was sitting on the lake. The rumour went around Blacklion that the Germans had invaded Belcoo.

Panic buying started in Enniskillen: people were buying flour and tea. Those who had experienced the First World War knew there'd be shortages. There were plenty of Irish-manufactured goods in Blacklion. People came to the pub for a drink and butter, which was rationed in the North. Cigarettes were rationed in the North and were cheaper here. There was a mini-boom all along the border for the war and into the 1950s.

I had an uncle who worked in Kyle's in Castlederg. If you were serving your time you had to sign an indenture. He was getting fed up there. I've a notion he let down the tyres of Kyle's car and struck off for Omagh. He was within the gates of the barracks and had signed up when Kyle caught up with him. He spent the last years of the war as a messenger boy: he was fourteen or fifteen, too young to go over the top.

In the 1950s there was huge emigration. We used to sell a lot of suitcases. They came from Dunleavy's in Donegal Town. One day in the 1950s, fifteen young people from Blacklion came in and bought suitcases heading for England or America. The country bled dry that time too.

I started here in 1962. There were three drapery shops in Blacklion and we're the last. During the Troubles, there were huge fluctuations in trade. There were rocket attacks in Belcoo and you wouldn't see people for three weeks once people got the habit of going somewhere else. It ruined thirty years of our lives. The tourist trade closed down. There were forty guards and three sergeants stationed here. They made up for lost trade. In the 1980s, petrol and drink got dearer and there was a huge rush across the border. We're up and down ever since. The big brands changed everything. They all want Nike, Adidas and football shirts now. Looking back, I was the youngest so you just did it. If I was in the guards I'd be out on a pension now.

Brennan's Pub,
Bundoran, Co. Donegal

Interview with Nan and Patricia Brennan

The pub was 112 years old on 17 March 2012. My grandparents opened it on St Patrick's Day 1900. My grandfather, James Ward, came back from America and stayed in a Bed & Breakfast on the Sea Road. This premises, which was owned by two brothers and a sister called Feely, came on the market. They had got a mortgage from John Myles in Ballyshannon to extend the front. The Electricity Board were taking over Myles' electricity business but they didn't want to take on mortgages so John Myles called in all his loans. As the owners were unable to pay, the business was put up for sale and my grandfather bought it.

He had met my grandmother, Katherine, before he went away. She was from Monaghan, and was working for her uncle Canon McKenna as a housekeeper. They married in 1899, and went to Derry on their honeymoon by horse and carriage.

Everything here is original: there's nothing changed. My granny made the rules, 'No television, no music, just conversation.' That still holds today when there is so much noise everywhere. Here you can chat or you can sit back and look around. That's what all pubs were. The bar used to be closed on Sundays but once the excursion trains started – sixteen trains came into Bundoran every Sunday – it opened between 1 p.m. and 8 p.m.

My mother took the pub over when she was still single. It was not unusual for a woman to run a pub. There were quite a lot of women running pubs in the town, but no ladies were allowed to sit at the bar, they had the snug.

The women went into the lounge; they didn't come to the bar and they rang the bell for table service at that time.

When she married James Brennan from Derryduff, they worked hard together. They were good days. They'd get up and bottle Guinness, everyone bottled Guinness. Whiskey came 100 per cent proof and had to be wracked: a process where we married it to water to bring it to 30 per cent proof. Then Mammy cooked breakfast for the visitors. The bar opened from 10.30 a.m. to 10.30 p.m. Mammy always dressed

Bar, Brennan's pub.

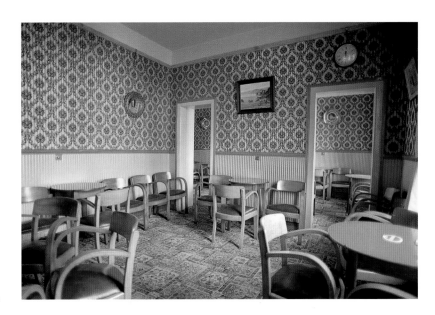

Lounge, Brennan's pub.

up in the evening: she wore a 'Shower of Hail' frock with a collar and reveres. She would sit or stand in the hall to help with all the people in the lounge.

As children, we all had our jobs, like bringing out bottles and washing them. Daddy trained us to do table service, but if you went into the lounge with a tray of drinks and came out without an empty glass you'd get told off.

When we were older we'd get a season ticket to the Astoria Ballroom in Bundoran. The season was from 16 June to the Harvest Fair of Ballyshannon, 16 September. All the great bands played there: Victor Sylveste, Joe Loss, Gay McIntyre, and Chick Smith. When we closed the bar at 11.30, we'd head for the Astoria until 1.30 a.m. and then back up the street to the Barbecue or Batisiti's for coffee after the dance, maybe an ice cream, or, if you could afford it, apple pie and cream. That was the 'Swinging Sixties' in Bundoran.

In the summer, the Scots came. The first fortnight was 'The Greenock Fair' because visitors came from Greenock. The second fortnight 'The Glasgow Fair', and the third fortnight 'The Paisley Fair'. They'd stay the fortnight and they were great. They could make their money last and go out every night. There were lots of hotels, The Sheen, The Imperial, The Hamilton, The Holyrood, The Great Northern, The Maghery and lots of places for Bed & Breakfast or full board.

During the day, in the Barbecue, there was a woman playing the piano and someone else playing the violin. Before that, Crowder's was the place to go. You might have enough money to have one bun. People dressed up to go there for afternoon tea. They had delicious cakes on a three-tier stand, with scones and buns on each tier and cake on the top.

In the 1960s and '70s it was hard work, but trade was good. In the 1980s, business was down but from the early '90s until the last two years it has been good. When the Celtic Tiger came, we didn't go mad. People began to build houses out in the country and they moved out from over the business. That was what the Celtic Tiger did: it took the life out of the main street. Times have changed: the new laws have stopped a lot of people coming to the pubs and people are lonely. In many places the postman doesn't call to the house anymore. Years ago you knew everyone on the street; you knew who your neighbours were.

We never regretted anything. We enjoyed every minute. If you didn't love and enjoy the pub business, you wouldn't stay in it.

Fishing Tackle Shop, Donegal Town, Co. Donegal

Interview with Charlie Doherty

My uncle was in the baking business. It was a family bakery: Doherty's. It was famous for the quality of its bread. He learned his trade in America. When my grandfather died he left the bakery to Thomas, another son, so my uncle came here and started a footwear shop. He was a keen angler; he tied his own flies and made fishing rods. The rods were made from greenheart, a hardwood, or built from cane: it was bamboo split and glued. Later on imported rods were made from fibreglass.

The quality of his flies brought custom. He took great pride in his work. Time didn't matter as long as the quality was good. Years ago there were more people fishing; money was scarce and it was a way to get something for dinner – not a sport, more of a necessity. Local people lived on sea and river fishing. Rass was salted and dried. There was no market for it so they ate the Rass and sold the rest. The Catholic Church forbade meat on Friday and anything that's a compulsion doesn't go down well, so people didn't take to fish the way they should.

I came to the shop when I was about twelve years of age. I left school at fourteen. My uncle died when I was fifteen, so I went behind the counter and I've been here since. I was always a keen angler; it was a big interest for me, so when I took over I discounted footwear. I made my own flies and fishing rods. When the cheap stuff came in from the Far East, you couldn't compete. Japan was a big exporter. The Americans set them up after the war.

'Jacob's Ladder' was one fly my uncle invented here; that was the most popular one. It was suited to the Eske River. The ones I make myself are 'Donegal Blue' for sea trout, 'Black Spider' and 'Goslings May Fly' for brown trout on Lough Erne and Lough Melvin. The flies are lures for the fish. You get 'Shrimp Fly' and 'Bluebottle' which resemble the real things and different patterns like 'Jock Scott' an old Scottish pattern and 'Garry Dog' used in the Finn River. It's not the salmon that differentiate but the anglers do. Some flies are more popular on some rivers. Rogan's in Ballyshannon was famous for local flies.

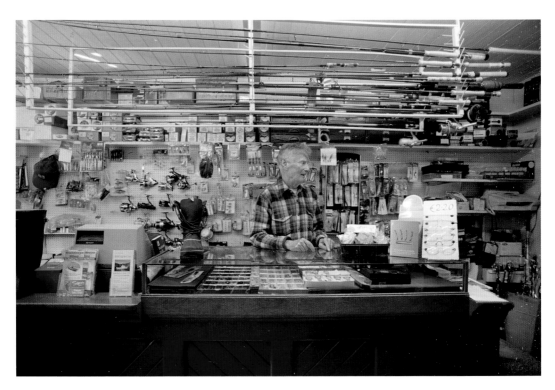

Charlie Doherty.

I was never interested in sport, kicking a football or hitting a ball on a golf course. With fishing, I could bring something home to eat. I won't go fishing if I have sufficient; I don't believe in waste of any kind. I hate to see mackerel discarded. There's not so many round here would eat pike. I fish for pike round Christmas then soak it in vinegar and water, next day I poach it. Pike is a robber. Mackerel? It's my opinion that fishermen put out bad stories about mackerel because everyone was catching mackerel and spoiling the sale of other fish.

The best bait of all is man hours. The fly that's in the water the longest is the one that catches the most fish. No one knows when they are going to bite. The fish could swim up and down not taking anything, then suddenly for about half an hour they'll bite and then stop – no one knows why.

It's a pity schools don't give children a taste of fishing to take them away from the telly. Mostly it's handed down from father to son or daughter. I like the solitude. Fishing takes us back to our Stone Age roots. It goes back to hunting instincts. Fishing can be addictive: the uncertainty, the gambling. If you know what's going to happen, it's no good.

Cosgroves,
Sligo, Co. Sligo

Interview with Kevin and Mary Cosgrove

Mary: There were many people here before us: Rooney's, Hartes, Cosgroves. It was built as a shop. Kevin's grand-uncle and aunt owned it, the Hartes. He had been a coachman and she'd been a housekeeper at the big house, 'The Hermitage', in the mall. They got married and took over here around 1890. At that time, this was the main street of the town. High Street stretched across the river and continued up Holborn Street to the Bundoran Road. Kevin's mother came here as a young girl from Maynooth. Her family worked on the Cartron Estate and had a cottage there, but she died when the children were all small. Kevin's father was from Belmullet.

I was a nurse in the hospital. I'm from Arigna. I trained in Guilford in Surrey and did my midwifery in Birmingham. I met Kevin in Sligo. He worked in Lipton's on O'Connell Street for eighteen years. His father had to pay £50 for him to be trained. When we got married we took over the shop. I had to resign when I got married, marriage broke all contracts. I was permanent at the time in Sligo General. I had to be there for nine years to get the marriage gratuity. You didn't think about it: everyone had to give up when they got married – every teacher, every civil servant, every nurse. At that time, there were only thirty nurses in Sligo between day and night staff. There were about 120 beds. They did minor operations: appendix, tonsillitis.

In the shop we opened at 9 a.m. and shut at 9 p.m. Sunday we worked 11.30 a.m. to 2 p.m. and 5.30 p.m. to 7 p.m. A lot of the smaller shops did the same. People shopped daily: the same women came in six days a week. Each morning up to lunch time would be very busy. In the past there was a restaurant here, the Eireann Restaurant. Lady Eireann is out on the street. The Hartes started the restaurant. They also had paying guests at the time.

Kevin: My father cooked the dinners – big sides of beef – in the restaurant. My sisters, Shelia and Maeve, worked in it too. I remember a lot of farmers came in from around Skreen. He served full dinners and desserts – we even made ice cream. I used to go to Ballisodare to get a huge slab of ice and take it back on the bicycle, then you put it into a machine and cranked the handle to break it up. Some of the ice would be kept in the shed. We'd cover it with sawdust to stop it melting. You'd break it up as you needed it.

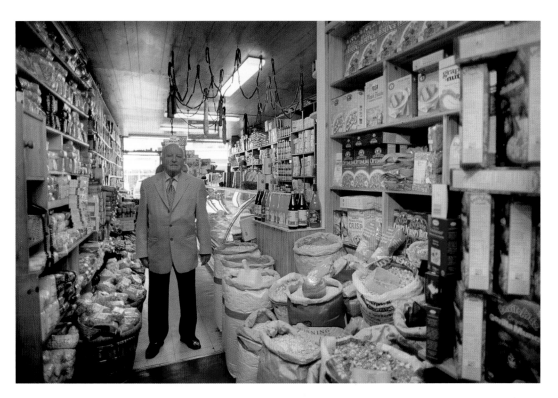

Kevin Cosgrove.

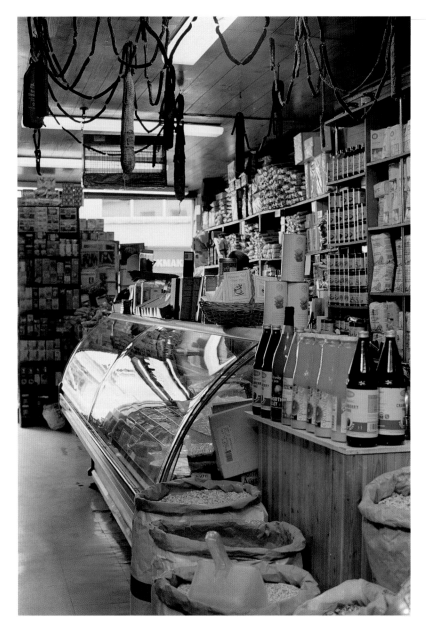

Interior, Cosgroves.

I was a Lipton's man: I worked there eighteen years. I had a bike. I was sent out delivering on Christmas Eve to Gibraltar, ice on the ground, falling off it – that was the game. I came up to the shop then to work with my father; we got rid of the restaurant and extended the shop out the back. They were good times but hard times.

There was a lot of poverty in the town; the children would often be barefoot. You could hear the slap of their feet walking down the hill. Then the Second World War came and everyone enlisted. The town was deserted as a lot of people left.

Then, in the late 1960s and early '70s, German factories came to the town. Women and girls got jobs and they spent money in Sligo and trade lifted. In the late '80s factories closed and people left again. The supermarkets came and there was a different type of trading. All the old shops are gone. Blackwood's was a famous shop during the war years: a wholesalers and retailers. Bellew's was another. Higgins and Keighron was round the corner and O'Connor brothers were in O'Connell Street.

We always had something special. We cooked all our own hams and still do. We sold special chocolate and Mrs Harte sold fine cigars and tobacco. Mr Hanly, the man who built most of Sligo, came in to buy cigars and tobacco. My father used to cut the tobacco from a big slab. Everything was parcelled up; you could tell where you were shopping from the colour of the paper. A woman used to cycle in from Ballintoher to sell eggs. People did that in those days. Her sons and daughters still shop here.

They were different times altogether. We developed the shop and now Michael runs it. He works hard. It was all work all my life: seventy-two years working.

Curios and Bric-a-brac, Rathmullan, Co. Donegal

The building is from the early 1800s. Originally it was a courthouse and it was used as a community centre. It was used for concerts, whist drives, weddings and card games. The back room was once the dispensary. I visited the dentist there.

I've always gone to auctions and collected but I had so much collected that I had to start trading. People buy things because it reminds them of their childhood home, an authentic part of their own life, like something their grandmother had in her home.

People change their style of living regularly now. Years ago if people bought a sofa or a bed, they kept it for years. There could be a revival for antiques; people might get nostalgic. For example, it is quite popular for people to buy old furniture to paint.

There are times I think it is like a museum. When there are lots of callers, but no one is buying. People like to know the stories behind things: where they came from and who owned them. Sometimes I do know if it's from a house I've known. I do house clearances and it's always interesting to see what comes up.

It started off as a hobby and now it's a disease, but it's a good disease; it keeps me going. I often wonder what I would be doing now if I didn't have the shop.

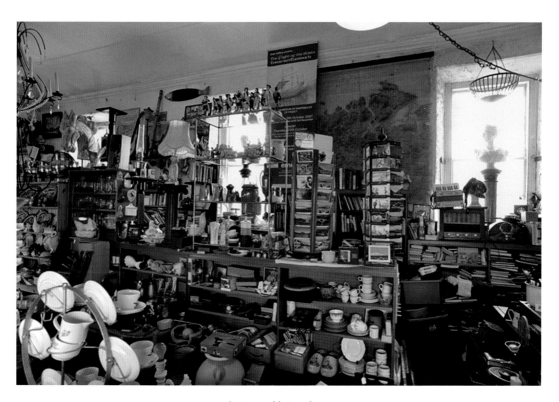

Curios and bric-a-brac.

Farrell's Café,
Manorhamilton, Co. Leitrim

Interview with Patrick Lunney

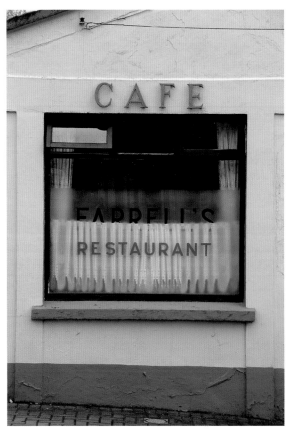

I met a woman from Glann, Noreen. We married in New York and decided to come back to Manorhamilton and bought the café. We thought we wouldn't be here seven years. That was forty years ago.

The Farrells were from Glenade. They started a restaurant and a second-hand shop here after the war. Kathleen and Madge were very industrious women and good cooks. In a small house like this they kept boarders. They were very progressive and changed the café more than I have. Kathleen Farrell stayed working with me for seven years. There was only one solid-fuel range. She made scones and boxty and rhubarb pies. She washed all the dishes by hand.

These buildings were army huts in Finner Camp. Someone bought them in 1926 and divided them into this row of six houses.

The busy days were the fair days. There was a famous fair on 8 May. You'd be very busy those days. People would be in early, around 11 a.m., for dinner. They would've been out in the air from 5 a.m. or 6 a.m.

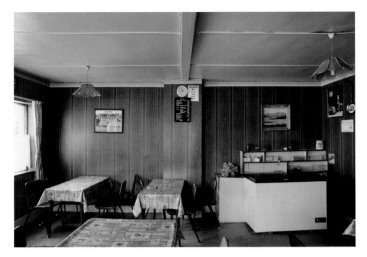

walking animals into the fair. The sheep would be tied along Castle Street. For dinner there'd be soup and a main course of meat, veg, and potatoes. We'd steep a big bucket of marrowfat peas. There'd be another big bucket of jelly and a big pot of custard. After the dinner and desert you'd get a cup of tea, two buns and a biscuit. Most people ate dinner in town because they were in for the day.

I kept an old menu with the old prices. There was a meat tea and a plain tea. The meat tea was roast beef, gravy, and, bread and butter, or, ham, tomatoes, and, bread and butter. The plain tea was bread and butter. I've heard it said that at hurling finals one man would get a meat tea and the other a plain tea and then they'd share the meat.

In the 1970s, the new comprehensive opened and the kids would come in for a bag of chips. I used to cut my own chips: they tasted much better. Now there's a lot more catering establishments in town.

Delis came in and working people go the deli. It does a big variety of things, like the breakfast roll.

It was hard work in earlier years. You'd be doing a long day until eight or nine in the evening. I used to do weekends but not anymore. I met a lot of people through the years. They'd give you praise. It was good to meet all the different people coming in. There's a different generation now, a lot of the people who used to come in have passed on.

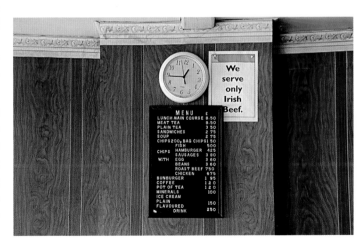

Thompson's Garage, Manorhamilton, Co. Leitrim

Interview with Harold Thompson

My grandfather, Jimmy Thompson, would've worked for a short time on the Sligo–Leitrim Railway, as did quite a few of the family. I only recently discovered the earliest reference to the business is an advert for 'Cycle repairs promptly executed and outfits provided' in the *Leitrim Guardian*, a short-lived local newspaper, on Saturday, 19 October 1907.

He married Annie Nixon and lived on the New Line, Manorhamilton from 1912. He started the cycle shop in his front room and had a shed out the back for repairs. He had a hackney for hire and he was into motorbikes. I remember him telling me a commercial traveller called in one day to tell him about a new product which would be a money spinner; it was petrol. Pratt's Petroleum was sold in a 2-gallon rectangular can with a brass top. The 2-gallon can was 1*s* 3*d*. A refill was 1*s*. It was sold in much the same way as we sell gas today. Prior to that, chemists had sold ethanol for use as petrol.

For a month, he carried out the cans to the pavement outside the shop and every evening he carried them in. He said to himself, 'What a fool I was to get involved in this.' But demand improved and by the early 1930s he had two petrol pumps for two qualities of petrol, Crown and Esso which had taken over from Pratt's. So he wasn't too long after the first petrol pump was installed in Ireland on Nassau Street, Dublin in 1923.

He started to supply bicycles. They came ready to be assembled in wooden crates. Twelve to a crate and cost £12. The first two crates he got, he assembled the bikes and sold them at £1 each to get established. I asked him why he made no profit and he said the crate was a valuable commodity and in demand as it could be made into a wardrobe. I could never grasp this until I saw one myself in the Ulster Transport museum in Cultra. If you put two hinges on the middle panel you had a wardrobe.

At some stage in the 1920s the current garage was built. It was on a green-field site. He approached T.R. Armstrong, a local entrepreneur, to buy the site. The arrangement they came to was that Armstrong would build the garage and my grandfather would rent it.

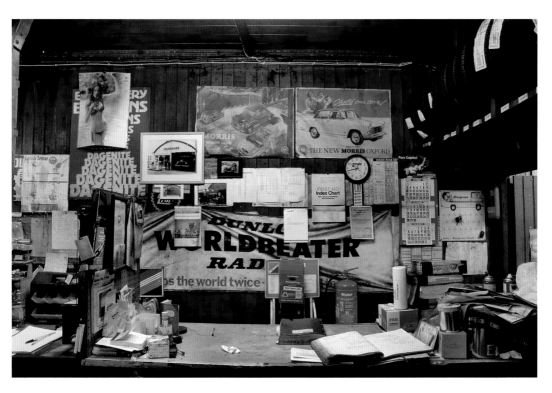

Counter, Thompson's garage.

Stenor volcanizing machine and tyre pressure gauge, Thompson's garage.

In the early years, a fully trained mechanic came to work with him. Then my father, George, joined him. I joined them in 1964. At one time, there were two mechanics, an apprentice or 'improver', a greaser, and a girl in the office as well as ourselves in the garage.

During the war years there was no petrol, unless you had coupons. The motor trade ground to a halt and bicycles were the mainstay. A system developed with a charcoal burner on the back of the car and gas was collected in a 'gas bag' on a frame on the roof to power the car, although you needed some petrol to get started. There was a black market; if you had the 'gas bag' no one knew if you were using petrol or gas. My grandfather never spoke about getting his hands on extra fuel.

Although my grandfather had ridden a tandem with his wife and taken Sunday trips to Garrison and home via Bundoran, his real love was for motorbikes. He had one with a side-car for his wife and son. One day he decided to race his brother Willie up the New Line and back into town. Such was his determination to win the race that he drove through an electricity pole and completely sheared off the side car. Luckily there was no one in it that day. We all inherited his love of cars and speed. I was involved in rallying and both my sons are enthusiasts; David competes in auto testing, which is another form of motor sport.

My father would've been driving the Hackney, doing trips

Workshop window, Thompson's garage.

Cabinet to hold the Castrol upper cylinder lubricant gun, Thompson's garage.

Engine gaskets, Thompson's garage.

to Bundoran or Sligo, at the age of thirteen. I was eleven or twelve when he gave me the chance to drive the car back from Bundoran. With his coat rolled up behind me on the seat so I could reach the pedals, I drove the car right to the garage. I worked in the garage in the school holidays and I just wanted to be there full-time, there was nothing else I wanted. After passing the Inter Cert., I spent one more term at school. In January 1964, I left the house to start the new school term, but instead I hid my schoolbag in a hedge and went to the garage. I never went back to school.

I enjoyed the garage for years. Mechanics had essentially stayed the same since the business started 'til the end of the 1970s. Modern technology moved in and now you have to use electronic test equipment rather than using your own skill to diagnose problems. For me that's taken some of the challenge and enjoyment out of it. I love working on vintage cars. It's a completely different mind-set to working on a modern car.

It's always been a family business; from 1964 to 1971 my grandfather, father and myself worked together. Now myself and David work together, and my wife Maureen helps us in the office a few hours every day. David recently expanded the tyre-fitting end of the business. My grandfather had been selling tyres since 1910 and we had a direct account with Dunlop until the 1970s.

I have a very loyal customer base. Some families would've been customers since the 1950s. People come back all the time because they get good value and good service. There's still a demand for the small, local, honest mechanic.

Kyle's, Castlederg, Co. Tyrone

Interview with Margaret Jack

My grandfather came from Fivemiletown, around 1900, and started the shop. At that time, they did groceries, furniture, undertaking, fixing shoes and auctioneering which my father carried on.

The shop burned to the ground on Christmas Eve 1937, the year my parents were married. My mother was in the bath when she saw flames going past the window. In those days the fire brigade came from Derry. They had to be paid before they set out so it was all burned, only the outer hall survived. No one was hurt and the shop was rebuilt in 1938. They thought that mattresses delivered on Christmas Eve were left too close to the generator and a spark had lit them. Some things were saved; they'd been thrown through the window and people caught them. Quite a lot of things were stolen. My father was a tenor. Medals he had won in Derry and my mother's engagement ring were lost.

I went away to boarding school, to Methody in Belfast. I had been ill so the doctor wouldn't allow me to travel to Omagh every day. I had a brother Freddy who died when he was seven. I was ill in one house, he was in the other. My grandfather was considered a strict, stern man, but on my first trip home from boarding school, he asked me 'Do you like school? Because if you don't, I'll get them to bring you back.'

I taught for six years, but I used to help out in the shop and lived here till I got married. When the children were small, I gave up teaching, and when my dad died, I was roped in more and more to the shop. We lived in the house over the hardware and my mother lived over the drapery.

The shop hasn't changed. Everything is seasonal; every year it is quiet at certain times. A lot of places have changed hands or closed in the town. I don't think you can survive being a specialist shop. You need a wide range, things you can't get anywhere else. We could have refurbished the shop or built up the stock. We chose to build up the stock.

The gas lighting is for emergency use. In the mid-seventies there were a lot of power cuts. On Christmas Eve, the lights went out so my father had the gas lighting installed. They still work from gas canisters.

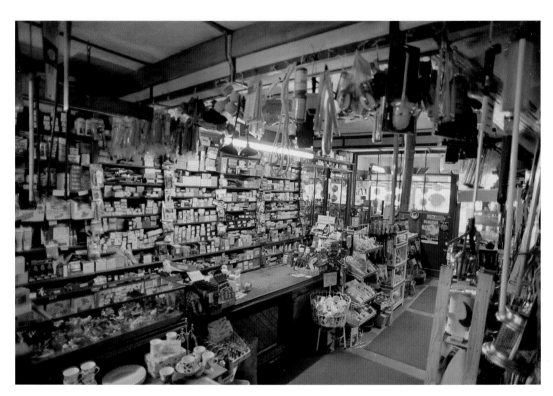

Aladdin's Cave, Kyle's.

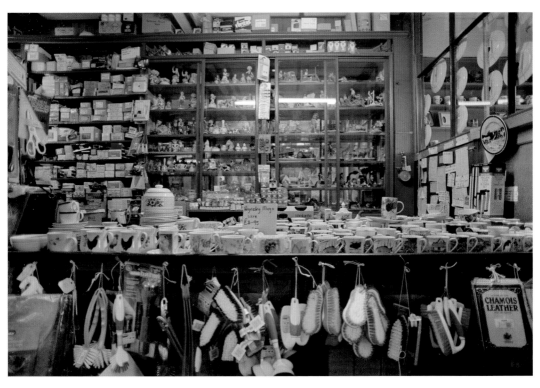

China, Kyle's.

Vest boxes, Kyle's.

The shelves in the hardware suit boxes, so that cuts down on pre-packed goods. The counter in the hardware is taken from the drapery shop, though it is a lot more scratched now.

In May 2004, we had another fire which luckily didn't touch the shop but devastated the stores at the back. We lost a lot of furniture and a lot of gardening stock. We rebuilt the back as faithfully to the original as possible, replacing old Bangor Blue slates.

People still come into the shop for parts for Tilley lamps, which are hard to get. We have globes for oil lamps although they are getting scarce. We had primer stoves which were destroyed in the fire.

Thirteen times during the Troubles our windows were blown out with bombs in the town. We could replace the windows, but the cracks appear much later in buildings so you don't know what damage has been done.

People sometimes come in to talk. We can carry on doing things and talk. People in the town always say, 'Hello Mrs Kyle', even the children. I say, 'Call me Margaret.' Two Australian women came in and said how nice it was to be able to talk to people in shops. They told me how when they were asking for cash in a bank they were directed to a machine, but they said, 'We don't want to deal with a machine, we want to speak to a human being.'

Clarke's Butcher Shop, Wine Street, Sligo, Co. Sligo

Interview with James Clarke

I've been here forty years. This place has been a butcher shop since the 1800s. You'd never get another shop like this; it's all changed with the supermarkets. We sell beef and lamb. There were shops selling pork, then shops for fish and poultry: Gallows on Harmony Hill and Flynn's on O'Connell Street. They weren't as greedy then.

At one time this shop was open to the street and the meat hung outside on hooks; the hooks are still there. Nothing is hung in the window because it all needs to be kept at 35 degrees. The sun shines in the window so the meat would go black. I still use the wooden Butcher's Block. A report from Galway University found that bacteria grows on stainless steel, but is killed on the wood. The old people weren't stupid; they knew what they were doing.

Young people prefer the supermarket where they can pick up the meat. They don't know what cuts to ask for. Everything is cut fresh here, T-bone steaks, roasts, the lot.

It's all our own meat butchered here: all heifer meat under eighteen months. Bullocks are tougher and used for export. You wouldn't get tripe in Sligo: it's all dumped. You might still get it in the south. Tongue is given to dogs. You wouldn't get many asking for it now. People aren't at home anymore. Women are out working and want something quick. Years ago, there'd be mutton: it was older had a bit of flavour. It's all young lamb and meat now. It's all killed young.

When I'm gone from here the show will be over. You wouldn't wish it on your worst enemy: it's cold heavy work.

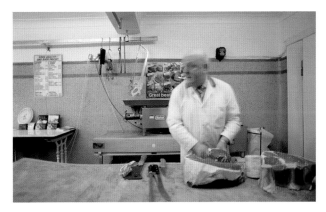

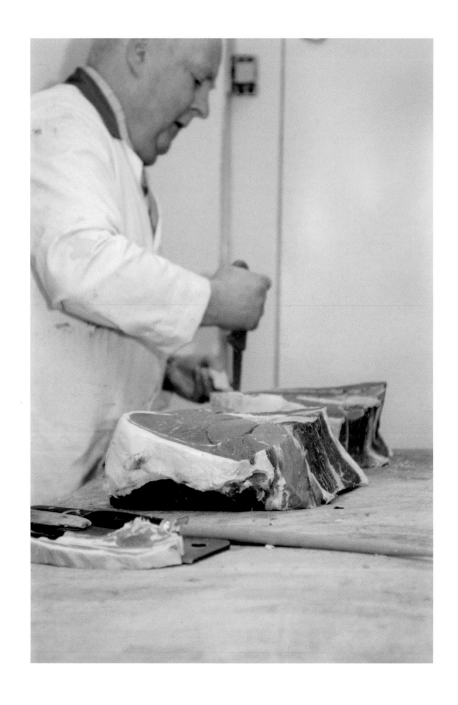

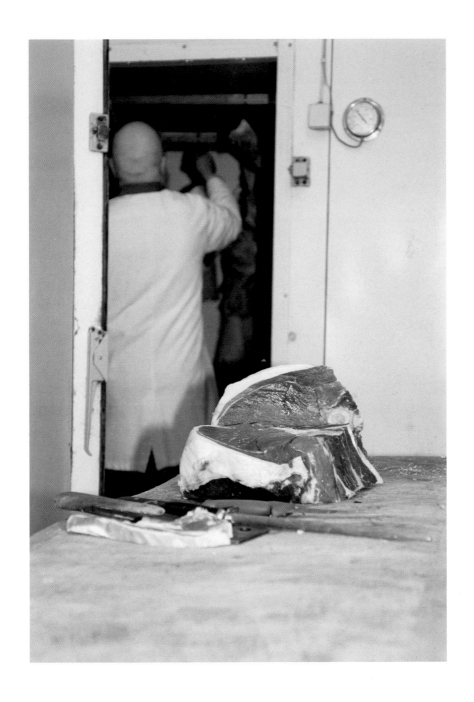

Coyle's Bakery, Manorhamilton, Co. Leitrim

Interview with Frank Kelly

Coyle's bakery opened in 1946. It had just opened before the severe snow of 1947. I started work there on 16 June 1949. At the time, it was a modern bakery.

We were confectioners. There were three ovens downstairs. They did plain batch bread, 'the pans'. I thought I'd be working with bread but I was making soda farls, queen cakes, jam tarts and Paris buns.

We made Hovis loaves. Special wholemeal flour came from Hovis and a fella came from Hovis in Dublin to give us a demonstration. We also made Christmas cakes and potato cake. There was more of that eaten in the bakery than was ever sold.

If I finished early I used to go off with the vans. The bread man used to do all the shops: a couple of dozen loaves to each shop and all the people came to that wee shop. I'd have to carry in the bread. They were agents for Gateaux in the 1950s. In the beginning we used to go to the docks and collect them from the depot every week. Later on a lorry would deliver them to Manorhamilton, Bundoran and Ballyshannon.

The bakery was hot and noisy work. When I started I had to come in at 8 a.m. then I had to come in at 6 a.m. and the fella who was making dough had to come in at 4 a.m. as they wanted the bread out earlier. Your hours were long and the pay small.

Former bakery interior.

There was an apprenticeship, but you didn't get any papers. There was plenty of craic going on in the bakery, I worked with fellas I'd been at school with. Plenty came and went for a while. My wife Mary started in the factory in 1960; we met there.

In the severe winter of 1947 there was no bread coming into the town, so everyone walked to the bakery or John Dominic Rooney's shop. A lot of people in the country were more self sufficient. They had potatoes, bags of flour in the house. They'd come in for salt, sugar, and flour. They had their own milk, bacon, ham and turkey.

People in town had very little. When the big snow came, the council were a fortnight clearing the roads. Bread couldn't get into to the town. Without the bakery, people would have starved.

In 1958, Manorhamilton got the County Championship but, by 1963, we couldn't put a team together as so many people had emigrated. There was a time when you could go into a shop like John Joe Rooney's until midnight. It was full of people and them all debating. It was a general store you could buy anything in it. He was an auctioneer and a travelling shop. He closed in the 1950s. The town had died.

Things changed in the bakery. I was only existing on the wages. I had to do other work so I decided to go to England.

Henderson's Hardware Shop, Donegal Town, Co. Donegal

Interview with David Henderson

My grandfather lived at the Craig down at Inver Port. He was a carpenter. He made everything there: cradles, carts, tables, chairs and coffins. My uncle started a saw mill. There were three brothers: one went as a joiner to rebuild Coventry after the war and my father, Jimmy, served his time in Andrews's hardware on the Diamond. He also worked in Gailey's in Castlederg. He left Andrews and went back to him three times. He had to leave him to get a rise. He worked with Ross Hamilton in Irwin's hardware until 1959.

My father opened his first shop a few doors down the street on the fair day in August 1959. There was only a small stock at that time. It was in the front room of a house. There was a lady boarding in the room behind. Later she got married, moved out and so the shop was extended. He had a pick-up truck sitting outside. The bank manager allowed him £100 of an overdraft and a number of people came in and gave him £10 or £15 credit to get something later. My mother died in 1968. I was thirteen going on fourteen. I'd already been part-time in the shop. I'd get out early from school and go to work in the shop. I left secondary school after two and a half years. The teachers went on strike. I went into the shop and I never went back.

We were always blessed with good and very loyal staff. One of the original staff was Patsy Mohan. He was spotted by a manager in Brooks Thomas who was so impressed he offered him a job if he ever wanted to move. He is in Dublin now. John and James McGroary worked here. Now John is a partner in his own business. Three Brogan brothers worked here; we've all remained good friends and keep in touch.

The counter was made for the original shop in 1959 and was moved to the new shop in 1970. My father made it along with the small step ladder kept at the end of the counter. There's been a change in trade. In the 1970s there were longer opening hours on Saturday. We used to open from 9 a.m. until 9 p.m. as most people came into town on a Saturday. There were no plastic bags, only parcelling with string and paper. Tommy Mc Groarty showed my dad how to make 'the poke', a paper cone to put seeds or nails in. It was

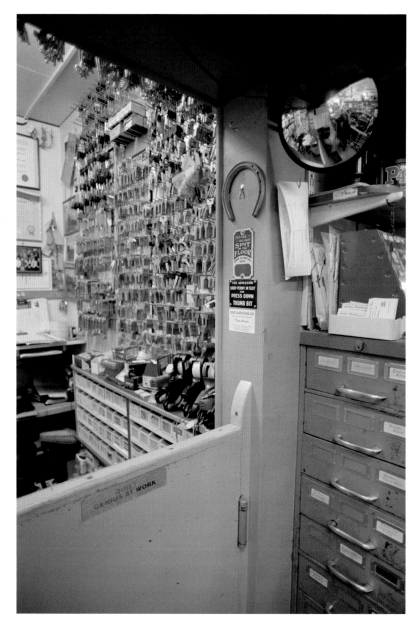

Keys, Henderson's Hardware.

Catch Boxes, Henderson's Hardware.

a predecessor of the plastic bag. Seed was weighed on these scales, which we still keep on the counter – there were lots of people buying seed then. We used to fix oil lamps. We still keep wicks. We would still supply wooden frames and wax sections for beekeepers, but there are only half a dozen people coming for them now and the number is dropping.

I developed the key-cutting and locksmith business. When I started cutting keys, there were only four different house types and three different types of car key, one for Leyland and two types for Ford. Now there are 400 types. We also cut keys for filing cabinets. It was always our policy to stock what customers needed. You can never gauge what they'll see when they come in. We help people and offer advice. The test of good salesmanship is whether the customer comes back.

A lot of small shops fail. They try to mimic the big shops: they get impersonal, they don't stock smaller items and then the service is no better. You've got to be offering something better than the big shops.

The social element has died out but there is still customer loyalty. Staff personality is important. We have Pauric, who has a boating background, and my own son, George, is full-time for the past year. My wife Dorothy has worked for over twenty years in the office.

There are changes, particularly with suppliers. The speed of suppliers has improved. It used to be a week or ten days after you placed an order it would arrive; now anything ordered in Dublin before lunchtime will arrive the next day. I miss the slower pace, being able to spend more time with customers. That was something my father enjoyed.

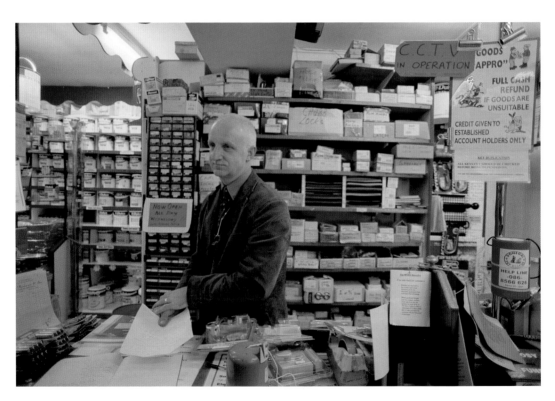

David Henderson.

Rogers and Lyons Shop, Sligo, Co. Sligo

Interview with Jan Patterson

I was there from the beginning. Mr Rogers was the original owner with Mr Lyons. Mr Lyons died and then Mr Rogers ran it. Myself and Mr Frank Foley worked in the shop. Then Mr Rogers died so Frank and I bought the shop. Vinnie Middleton came to work with us and has remained in the shop ever since.

Well, I loved the shop. I loved the shoes and I loved the travellers coming. We never went in for cheap stuff; we liked good shoes and they will be expensive. My favourite shoes were a green pair; I wouldn't give them away for gold. I had every coloured shoe. I'd love to be down at the shop. I could show you the shoes I like, but I got sick and I've been off work for a good while. Oriel, my niece, has always been very good to me. She looks after the shop.

It was lovely when visitors came, holiday makers. They'd come from America and they'd be over from England. You'd get people every year coming back to Sligo and it was like seeing old friends. You'd greet them at the door with your arms open. You'd love to see them coming back. It didn't matter what trouble you went to for them; if they didn't buy, they didn't buy. Very often they came back again to see a certain shoe and to buy. 'Will you show me the shoes I had on with the pointed toes and the medium heels. They were lovely.' Then you'd give them a tin of special polish – that was good discount – and they went away happy.

The customer always got the good chair with the cushion. Make them comfortable and then sell your shoes.

We always repaired shoes and they were well done. We made gaiters . They could button up the legs to keep you warm and dry. They were a speciality just for the nuns.

The shop was always swept before we closed at night and swept outside every morning. It was a nice clean shop. The Queen could come, and she'd be welcome, and it was clean enough for the Queen.

We never changed the shop. Why put a blue curtain on the window if the other fellow does it? Do it your own way. We kept the sign. Why change it? People knew it as Rogers and Lyons. As long as the names were there people remembered Mr Rogers and Mr Lyons.

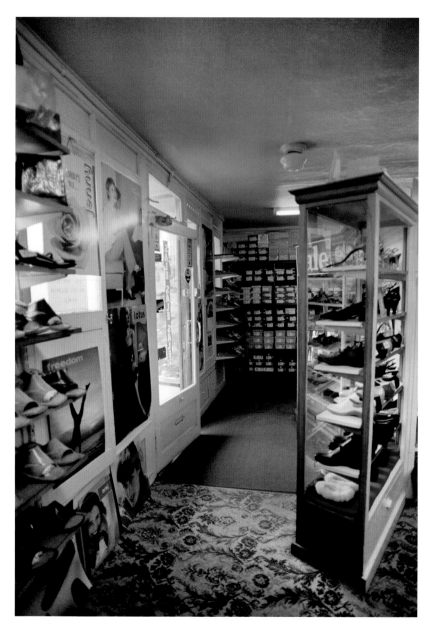

Interior, Roger and Lyons.

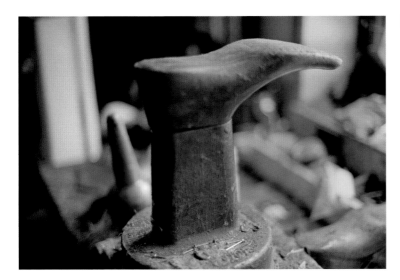

Metal last, Roger and Lyons.

It was always a shoe shop. I went to work there after school. When Frank and I bought the shop some people said, 'you'll be in it nine months,' because I was a woman and there were people who were jealous, but my customers came back year after year.

I have no regrets. I was meeting friends they came to see me and the shop; that's what mattered.

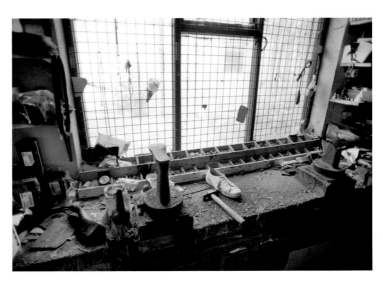

Workbench, Roger and Lyons.

Garrison Post Office and Shop, Co. Fermanagh

Interview with Mary Ferguson

It was March 1985 when we bought the premises. Mrs Kathleen O'Hagan had died and the place remained vacant for many years. I had the post office in rented accommodation across the street. It was part of the hotel that was bombed in the 1970s, The Melvin, owned by McGoverns. Another well-known hotel across the street was Casey's.

There was once a whole pile of shops in the town: Mc Garrigles, O'Briens, Carty's. They were all grocery shops. There was a Pat Brewster who did second-hand clothes. Many's the one got decked out in it. Miss P. O'Hara had a drapery. She had a good flair for picking clothes.

Mrs Shelia Tracey had a tiny shop. In a small space between the hall and shop she had everything: balls of blue, methylated spirits, food. She could put her hand on anything. Two people and the shop was full. God she was great. Up the yard she had baling twine, silage wrap. She had everything going, everything you could name.

This shop was a grocery and hardware. Mrs O'Hagan improved the shop in 1955. She had terrazzo marble put in on the floor but she was wise enough to put wooden boards behind the counter where she was standing.

My mother used to shop here. Mrs O'Hagan was a great lady. There was no rush with her. She chatted to everyone and she could talk. It wasn't heard of to go to Enniskillen. The O'Briens had lorries on the road going out with animal feed and coal. Everything was available to you here. Now, if you were looking for it, you'd hardly get a spool of thread.

When we came it was going to be just a post office. We had to pay rates on it so we thought we might as well use it. We started off with sweets and minerals, then people would say, 'have you no bread?' Then they wanted sugar and butter. As they asked you got it, so you broadened out. That's why it stayed the same. If we'd decided from the beginning we were going to have a shop we'd have completely changed it.

In Mrs O'Hagan's time there were a lot of southern customers. We didn't see each other for years when the roads were blocked. Nobody came over. It was a long drive round. We thought, when it opened up, all

Interior, Garrison Post Office.

those people would be back. They only came at first for the novelty. I think it was the euro; the different money put them off. I would see a few people when I go up to mass in Ballagh.

I did get the British Empire Medal for all the robberies. There were six robberies here but no one ever got hurt. In the last one I was standing here behind the counter. There was an elderly woman over ninety in the shop. I looked up. The door opened and three boys with masks came in. One kept the old lady, the other John, and the other tried to get the door open. One of the girls shouted, 'Please open the door.' Eventually I opened the door. He took out cash. They made their getaway and turned down the street with guns through the window. The others were all in the time of the Troubles. I got the medal in Hillsborough. It was all low-key at the time as people were afraid to talk. In the height of the Troubles times were hard. You couldn't serve the army or you'd be burnt out. People were afraid. It's hard to forget.

We've to be here at 7.30 every morning. Two postmen come in to sort it out. At one time there were five postmen – they were all on bicycles – but the jobs were reduced. It's hard to compete with the big shops. In the big shops you miss the friendliness. You get your stuff and you go on; you won't hear who's ill or who isn't.

I hope to retire shortly. I would miss it of course: I'd miss the laughter and jokes and you do get some laughs here. You think you can't be done without, but you can. A man here told me, 'when the grave is filled in and they turn away you're forgotten, apart from your family.'

Joe Gallagher, Main Street, Letterkenny, Co. Donegal

Interview with Joe Gallagher

I started work at fourteen years old in Limavady, Co. Derry in 1942. The war was on and the stock was very limited. People would cross to the Republic to get tea and butter. I enjoyed working in the shop from the start. You had to get an apprenticeship. For the first twelve months I earned £5, the second year I got £10 and in the third year the wages were £20. The people I worked for were very good. If I wanted to go to a match or a dance they'd give me the extra money.

From 1952 to 1962 I worked in the Irish Agriculture Wholesale Society, right beside where I live now. I opened my shop in Main Street in 1964, it was a good strong shop that had been going about 100 years. It was a challenge in Letterkenny at that time: the shops were open until 8 p.m., seven days a week, but it was very sociable most evenings the main street was full of people meeting and shopping from 6 p.m. in the evening. You didn't see much money; for the first ten years we worked a lot on credit. There were a lot of good shops in Letterkenny, from the bottom of the town all the way up Main Street: tailors, grocers, drapers, lots of different shops.

In business, you've got to be as good as the next person. The opposition is out there, that makes you go on. To give up would be a disaster.

I think it's scandalous what has happened in the country. The money has been taken from the people and given away. People can't get credit from the banks and money is needed for people. If you don't have money you can't have anything. This recession is not as bad as in our day. In the past, people went to Dublin, England or America and they sent money back and that kept people going.

In the future the small shop will be gone. No one is going to take on the challenges we did in my day. There'll be a limited number of shops for specific things but the general store will be gone.

In Letterkenny everyone knew everyone. It's limited now, a whole new scene, people are gone away from the old way. There's no relationship between the people; they don't have what could give them a good

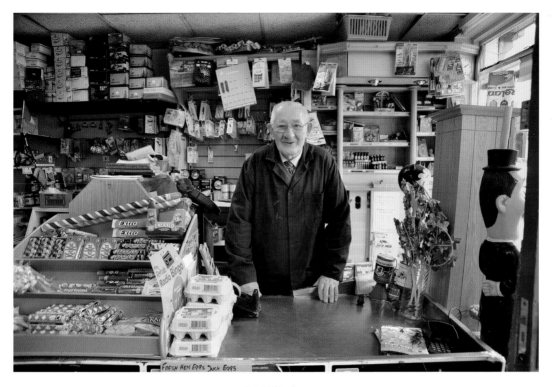

Joe Gallagher.

life. People are rushing all the time, chasing all the time, and everyone's looking out for themselves. In the past, people worked with one another and that was a great life. You'd have time to go and meet people and talk with them. If you helped someone out, they came and helped you. It was part of social life; it was the whole basis for the way people lived.

I'm delighted I lived when I did. I've had an interesting life. People tell me they're living in bad times, I say 'Where's the bad times?' You have better conditions now, but in the past people understood each other and worked together. They didn't waste things. They held onto what they had.

A lot of shops are gone, but I still work on, when that's your life you have to do it.

Workshop at St Conal's Psychiatric Hospital, Letterkenny, Co. Donegal

Interview with Hugh McCauley

This room started life as a big dining room in 1886 when St Conal's was built. It was the main dining hall for the working patients who lived in the wards and went to work on the farm. St Conal's was self sufficient; they had their own beef, milk, and vegetables. Most of the clients came from a farming background so it was great for them to be working on a farm. They'd come in here for breakfast, dinner and evening tea. It doubled up as a theatre, cinema and dancehall.

There were 800 patients here at its peak and 'The Tops of the Town' show was the biggest thing to happen here. There were teams from the town going through to the national finals. The money collected went to the patients comfort fund. There was also a staff boxing club and the ring was put up in the hall.

Jim Gallinagh started the workshop in the new building in the early 1970s. He was one of the first staff to train in occupational therapy. He worked here until his retirement and was followed by Mick Gallagher until 1995. P.J. Mc Gettigan worked here until 2005 and I've been here since.

In the early days we made stools, coat hangers, cots, wheelbarrows and hobby horses. P.J. developed the garden furniture and framing and I started making customised furniture, beds, wardrobes, and chests of drawers. We made the boat for the Flight of the Earls festival in Rathmullan. We make things for the

Workshop in old dining hall, St Conal's.

Letterkenny Musical Society and Errigal Arts festival. We don't need to advertise. It's all by word of mouth and we've plenty of work.

The workshop pays its own way. People enjoy working here. It's the same for everyone: we all need work to give a structure and meaning to life. This is a rehabilitative shop, everyone gets satisfaction from creating and making things and there is great pride in the work. I started here in 1978. There would've been about 800 patients here and 300 staff. It was like a wee town. It was people's home. Staff lived in the nurses' home or in the semi-circular rooms at the end of each corridor. In the past, there was a wall around the hospital and a gate lodge. Staff had to get a pass to go down the town on their days off. There were dances and bingo. Christmas here was a blast with parties from 3 December until New Year's Eve. You'd be wrecked.

The service divided into smaller areas and that sense of camaraderie was lost. The New Building closed in the '70s. Some of the people who lived there worked down the town. People moved back to their own communities and some people were more suitably placed within Learning Disability Services.

Some people say that this was originally built to a plan for a British Army barracks, and that there is a depth of sand between the floors in the New Building. That may be just a legend. However, I do know that there is a depth of wax between the floors in this building. When I first came here staff and patients did the domestic work. There was

a system called 'blocking', using a long stick with a block of wood on the end covered in a blanket to polish the floors. A nurse spilled liquid wax on the floor and the patients pulled the covered block over the floors to polish them. Over the years, wax dripped between the floorboards into the space where the joists are and it built up in some places to a depth of six or seven inches.

St Conal's offered phenomenal employment to Letterkenny. It was a very institutional place to work, there were many rules pertaining to dress and behaviour. If a staff member was caught drunk down the town they would be sacked. Male and female staff were segregated and instant dismissal was the punishment for being found in the nurses home after 'lock down'.

It was often called Tír na nóg because the patients were well cared for. All their needs were met and, with good medical care on hand, many lived to a very great age. In one way it was a comfort and in another way it wasn't because you need to be independent and able to care for yourself. Both patients and staff found there were challenges when the move to community came.

Henderson's Music Shop, Derry, Co. Derry

Interview with Brendan Henderson

We opened our first Henderson Music Shop in Foyle Street, Derry in 1969. When our shop was damaged due to a fire bomb at adjacent premises we moved to Bishop Street in 1979.

This shop was previously a drapery shop known as J.F. McDonald's & Co. Drapery. Prior to that, it had been a hotel. The old basement had a big cooking range with a 'dumb waiter' to bring dishes up from the kitchen. A good number of these old buildings in Bishop Street were operated as small hotels as there were so many merchants coming to Derry in the eighteenth and nineteenth century, with the nearby Diamond area being the main 'hiring fair' for Derry, Donegal and further afield. Underneath the streets, within the walls, you have an array of connecting tunnels that people would've used for safety during the Siege of Derry when the walled city was under siege from the army of King James.

Our father, Hugo Henderson, who was also a piano tuner and technician died suddenly in 1960 from heart failure. He had started life as a piano tuner in the early 1930s and soon developed a significant reputation throughout the country for his piano-tuning skills. Sadly, just a month before his death, he had agreed to rent his first piano shop in William Street, Derry. Up to this point he had sold pianos from home and also refurbished pianos for customers.

He was born in Lifford, Co. Donegal and was a talented musician playing accordion, piano, saxophone and clarinet. He played in local bands with his four brothers, who were all excellent musicians. Notably, his brother Jim Henderson played clarinet with the Melody Aces, a dance band that successfully toured America in the late 1950s and early '60s

Five years after Hugo's passing, when Brian was sixteen he began his piano-tuning apprenticeship with Craig Reid Pianos in Cromac Street, Belfast. My mother, Kathleen Henderson, wrote to all the UK piano companies my father had dealt with, to help find a position for Brian. One of these companies, Goddard & Goddard recommended him to Craig Reid.

Kathleen gave Brian his father's piano tuning tools. These tools had been accumulated over many years and were kept in Hugo's original tool case. I remember playing with the tools as a child as if they were toys.

The heavier tools and spare parts were placed in the bottom tray with the lighter more intricate tools stored in the top compartment. The tools were gathered over the years: some were bought, a lot were handmade. My father knew what he was trying to achieve and he'd make something to suit the purpose if required.

My mother was the cornerstone of the shop. She had twelve children and worked in the Bishop Street shop until the day she died in August 2003. She was the motivation behind Brian's progress as a piano tuner and achieving Hugo's wish to set up his own piano shop in Derry.

People worry about recessions. During the late 1970s and '80s things were very bad. We were only selling pianos, so we diversified into smaller instruments, church organs, and music books. Some people think no one buys pianos these days but we enjoy good sales. When we visit other family members the piano is still the centre of attraction.

The piano I learned on was in our house since 1948. It was sold to a customer in the early '70s and, in 1996, we accepted it back as a trade in. It was a joy to see and play this Collard & Collard piano after so many years.

We do a lot of refurbishment work to pianos. Ivory, for example, is a brittle substance which absorbs moisture from the fingertips and is prone to chipping. So if there are no chips on the ivory keys, it is one way of judging if a piano has been cared for. We keep salvaged ivory keys which we use to match when we are restoring pianos.

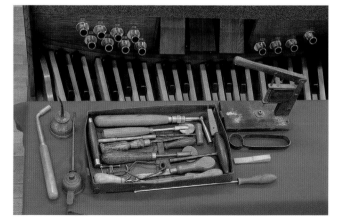

Tuning tools.

A piano tuner usually leaves his signature and date under the keys when the piano has been tuned. It is a real joy to see my father's name on some pianos which arrive in our showrooms from time to time, with dates going back to his time as a piano tuner. Being taught how to tune is only the beginning. The foundation of tuning is based on acoustics, where you use your ear to listen to the tone the tuning fork will make and transfer that tone in your head. If the piano is under stress you take it to a 'happy place'. This means that if a piano cannot be raised to concert pitch, you can detune to a lower pitch where it is not under stress. Knowing when to apply this method of tuning is an art in itself, as it is learned over many years of acquired experience of tuning pianos of all qualities.

Magee's,
Donegal Town, Co. Donegal

Interview with Jim Wray

I started working in Magee's on the 1 April 1962. I started in the old Magee's before they extended. The old shop had all wooden fixtures, drawers to pull out, wooden shelves and glass doors. Suits at that time were mostly black, grey, or light grey and there were tweed jackets. The first one I sold was £7 10s, and you'd pay £8 10s for a real upmarket worsted jacket. The jackets were made in Belfast. When the clothing factory opened, men went to Belfast to learn about tailoring. It was the time of the start of the Troubles and the cars of men going over and back across the border aroused the suspicion of the army.

Mr Lytle was my boss in menswear. Mr Rowan was the manager. It was very businesslike and the important thing was sales: you had to be sales minded. It was based on personal service. You had to get what the customer wanted. They used to say, 'a customer is a customer when he comes back a second time'. It was very hands on. Mr Howard Temple would come and check everything on the shop floor. He made notes in his red book. Problems were taken care of, complaints followed up to the utmost, but I remember letters of thanks coming through the management as well.

The world knew Miss Little. She was the manageress in the ladies department. She went to church dressed in her tweed coat and scarf. She knew Magee's inside out and was dedicated to the firm and she would have been involved in design as well as going over orders. Letters were written back to Miss Little thanking her for her help. She was work minded and called the staff 'her girls'. Getting her home in the evening was the problem. Miss Little didn't retire. That word didn't come into it and I never remember her going on holiday. She might take a day now and again.

The Magee sale was the thing. My job was putting up posters from Ballintra to Killybegs and as far as Barnesmore. We didn't go beyond Ballintra because that was Slevin's area. The poster would advertise the main bargains. You had to paste them and put them on an old house or wall. You'd to watch private property and occasionally I'd get a complaint so I'd go and take it down again.

When there was a sale, you wouldn't get moving in the shop. Back then people bought if it was a bargain, now they only buy if it's necessary. In those times you'd heard of Letterkenny, Ballybofey, but you never went there. You stayed in the town and shopped locally for groceries and drapery. People went to Floods for cars, or R.F. Johnston. Bobby Sturdy, an estate agent, went to Friel's of Creeslough to buy his car and many's the time I went with him when he went to get it serviced.

I met a lot of people in the shop: Jack Lynch, Charlie Haughey, Garret Fitzgerald, and Gloria Hunniford. Once when Garret Fitzgerald was in town he said, 'Go up to that fellow in Magee's and send me down a few suits.' We brought them to the hotel to him. Another satisfied customer.

I used to dress the windows and, in 1977, we won the All-Ireland shop-front competition. Previous winners were Louis Copeland and Hackett's. We won £500 so we had an outing. John McGinley coaches took us to Lough Key Forest Park where we went boating on the lake. We'd stopped for refreshments on the way and it was tricky enough getting everyone rounded up in the evening.

I was never late a day in forty years. I enjoyed it all. I enjoyed sales and I often had the highest sales figures, for which we got a half yearly bonus. We were trained never to say no. I was cut out for it and given the chance I'd do it all again.

Tweed inspection, Magee's, 1991.

Interview with Lynn Temple

Magee's started on the site of the current shop, on the Diamond in Donegal Town in 1866. Mr Magee ran a drapery shop and he went around fairs buying hand-woven Donegal tweed. Tweed was sold on the fair days along with livestock. Magee acted as a merchant, buying and selling cloth to tailors around Ireland. My grandfather, Robert Temple, came from a farming background in Killygordon. He bought the company in 1900. At that time it was just a drapery and a small wholesale tweed company.

Robert Temple started buying cloth from Convoy Woollen Mills and selling it on to the trade in the UK as well as tweed. When Ireland was partitioned in 1921, he established a warehouse in Belfast to supply the UK market and the goods went to Belfast by train. My father, Howard, came into the business in 1931. At the end of the Second World War, he could see the decline of the bespoke-tailoring trade and he set up a manufacturing business in Belfast on the site of the warehouse. Magee specialised in colourful clothing, based on tweed. At the time it was said that Burton's were shelling out thousands of 'grey demob suits' for 50s so they weren't in competition with them.

Originally the family lived above the shop. My father had an air rifle and would shoot crows and jackdaws off the roof of Dunleavy's across the street. In the 1911 Census Miss Little is listed as one of the apprentices who also lived over the shop. Miss Little was an iconic saleswoman. She attracted a lot of custom to the shop.

It wasn't until 1960 that tweed was sold into the fashion market. Until then it was utilitarian; it kept people warm and kept the damp out. Irish fashion designers like Sybil Connolly and Irene Gilbert used tweed in their collections and it's gone on from there. Magee weaving is still going strong in Donegal, selling into the worldwide designer market. The Magee shop still reflects the 145-year-old heritage of Magee but in a contemporary way.

The future is about making a very old company adapt to a changing market. We have great youth, talent and enthusiasm in our weaving and clothing design and marketing teams. My daughter Charlotte is, along with the team, developing the range of merchandise, giving the heritage a contemporary twist and focussing on how we sell it, including through a good Magee website.

Killasnet Creamery, Manorhamilton, Co. Leitrim

Interview with Tony Gordon

Sealed letter, Killasnet Creamery.

I started work here in 1972, that time it was considered modern. They were manufacturing butter and selling it in pounds wrapped in greaseproof paper with Killasnet written on it. Milk came here from Blacklion in Cavan, up to Ballintoher in Sligo, and as far as Calry and Kiltyclogher. It was collected in churns.

That stopped in the late 1990s and tanks were used. By then, the suckler cow scheme was introduced and that encouraged a lot of people to get out of milk.

Sean McPartland was manager here when I started and John Drumm was the assistant manager. There were about fourteen people working here: John McGurran taking in the milk, Seamus McManus on the churns, Red John Rooney on the lorry, and Jim Ferguson.

The milk started to come in at about 8.30 a.m. They'd be waiting at the gate and the intake could last up to 2 p.m. You'd weigh it first, then test it for butterfat content: that's what people got paid on. A sample was tested twice a month. About 3 per cent of the milk would be butterfat. It depended on the fields.

Then the milk would be separated. It was released into a 400-gallon vat. The cream would come to the top as it's lighter. Two pipes siphoned it off. The skim would come out on the bottom. In 10 gallons of milk there'd be 9 gallon of skim and a gallon of cream. It was all pasteurized. The skim went to making powder for feeding calves. The cream was stored, repasturized, pumped into 600-gallon steel churns, and then it was left lying overnight. Six hundred gallons of cream made 2 tons of butter. With the daily intake we were

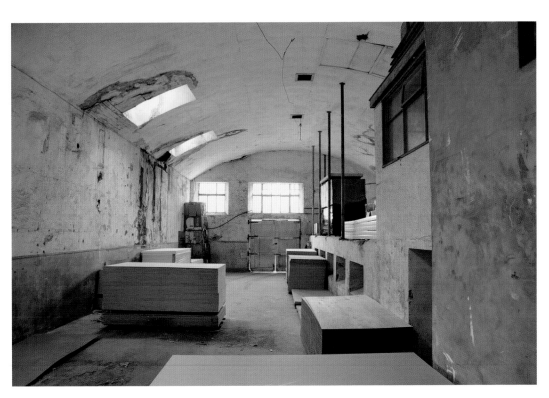

Former milk production area, Killasnet Creamery.

Pippets and letters, Killasnet Creamery.

getting about a ton of butter a day. Milk came in every single day to the creamery. Butter was made every day except Sundays and Bank holidays.

The churns were very noisy. I'm surprised we could hear at all with the separators, churns, and milk pumps going. The churns spun for about two hours, then a half ton went into pound wraps and they were sold locally in Leitrim, Sligo and Donegal. About 6 tons went into 56lb boxes lined with a blue wrapper and sealed by hand. These boxes went into cold storage in Sligo and Monaghan. You heard of the butter mountain. In the end a lot of it was given to Russia or the Developing World. In the winter, other diaries could buy back butter to sell under their own labels.

Killasnet was an independent creamery with several branches: one in Glenfarne and one in Creevylea for taking in milk. The wee dairies got pushed to one side. When Ballinafull and Drumcliff wound up, they took the butter-making here. Eventually though, the government wanted unsalted butter and it wouldn't be top quality milk here for unsalted butter. Hygiene got very strict; it got over hygienic.

When they stopped buttermaking here, they sent the milk to Ballaghadreen for processing. The milk quotas had an effect. It wouldn't make sense for people to buy quota and try to produce milk here. You'd have to go to Blacklion or Dromahair to find one person producing milk now. There isn't a sinner kind in Manorhamilton in milk.

This was my first and only job. I wouldn't change a thing, not a hate. It was great craic. I was happy for the whole time.

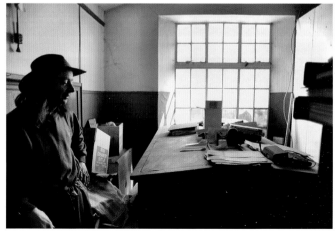

Tony Gordon in the old office, Killasnet Creamery.

Pippet, Killasnet Creamery.

Christmas Tree Shop, Donegal Town, Co. Donegal

Interview with Aidan O'Donnell, Jim Feely, and Eamonn Kelly

The Christmas tree story would've started while we were in the old department, Agriculture, Fishery, and Forestry. We were the Forest Wildlife Service when we opened one of the first Christmas tree depots in 1988. It had originally been at the old technical school.

Traditionally the Christmas trees for this part of the world would've been Norway Spruce and Noble Fir. Noble Fir is regarded as the king of Christmas trees. Because there wasn't much Norway Spruce, we introduced Lodge Pole Pine as a second. It was non-shed and people really latched onto it. At that stage, we grew and felled our own trees. Special corners of the forest might be used to grow Noble Fir.

Once we became Coillte, a semi-State company, they bought good quality land, better than the rough mountain land used for forestry, and set up Christmas-tree farms for home and export. They concentrated on Noble Fir and Normandii or Norman Fir and the Christmas tree unit became a unit within Coillte. They supplied all depots. A farm outside Elphin supplied us.

The Noble Fir has been set out as a Christmas tree because of its shape. It has branches that stand out like the upturned palms of your hands, so they are ideal for decorating. Other countries in Europe envy the way we can grow it. They can't get it to grow at the same speed and they don't achieve the same form. Norman Fir was introduced in the last five years or so. It grows well. None of them are native trees. Lodge Pole Pine is from the west coast of America. The only native pine is the Scots pine and the one found in the bog is Scots Pine. There are only twenty-seven native species of trees in Ireland and some of them might only be shrubs. Trees like Beech have been here a long time but they're not native. Around Donegal Town there would be a strong tradition of trees and a recognition of their usefulness. There is a history of woods around Lough Eske, Rossylongan and Ardnamona. On these estates trees were grown, and more importantly they were managed.

In the local depot here, Jim Feely was a member of the staff in Lough Eske Forest and Jim took on the day-to-day running of the depot, deciding on tree quality and dealing with the public in general. That

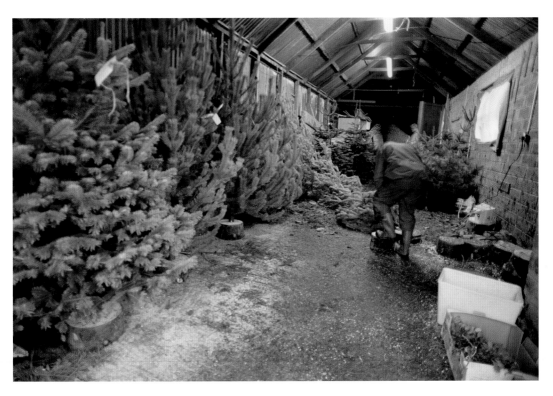

Christmas tree shop.

was his role for December and he was ably assisted by Eamonn Kelly. Jim and Eamonn have over twenty years experience involved in all aspects of forestry. One of the problems that emerged over the years was securing a depot. We were thankful to Liam Clancy of the Abbey hotel for the use of this shed.

Jim: This was originally a hardware store. It was a big place belonging to Tommy Hamilton – a general hardware store. It closed about thirty-five years ago when they moved beside the Abbey Hotel. Christmas trees are very important to everyone who comes in. Everyone is different in what they need. As years go by you know exactly what people require.

Aidan: We were probably the first depot. It became an idea we thought worth trying. Myself and Dennis Gallagher were getting enquiries from people who wanted to take trees and sell them in Dublin.

Jim: At that time, there were no trees. When I was growing up maybe there was a candle in the window, that's all.

Aidan: Or people might take a branch and set it upright like a tree.

Jim: A Christmas tree takes a few years to get going. In the first few years it doesn't do much – it takes a long time to get established – about ten to twelve years. When we were growing them, we used to shape them and slow down their growth. We'd slow the growth by cutting the bark in a circle down near the root. We'd use a scribbling knife and take off about an inch, then leave a small bit of bark so it grew back. We did that so they'd get more nutrients from the soil and they'd fill out. We used to shape the external branches. It was very labour intensive.

We used to harvest around the middle of November. By the time we'd harvested and extracted and got them to the depot, it'd be the second week of December. Now we open in the first week of December. The

first two weeks here were very busy. Perhaps people are coming early to have a better choice. We'll close on 22 December unless we run out before that.

Eamonn: I started work with the Forestry in 1981. I'm from Pettigo. At one time there were sixty men employed in Forestry from Pettigo. I'm the only one left. When the forest service was in operation, we had our own areas but now we have to travel to where the work is. I used to own a mountain, Crockbrack, in Pettigo, round the back of Lough Derg. But it was a good way to go to look at stock, so I sold it to Coillte. It was around 350 acres.

Aidan: Setting up in 1988 was the first time we diversified from the core business and took a service to the public. It was good PR. The public got to meet Coillte people so we could hear about small problems and sort them out, and then Coillte could tell their story.

Coillte are very conscious about the environment. Everything has to be sustainable. The staff are very dedicated and passionate about trees. When I went away to college at seventeen, I knew nothing about trees, but in a very short time you became very serious about trees. We realised that trees were not just about timber but all the other benefits; how trees impact on people's health and welfare. Trees are like scavengers, they clean the air, taking in toxins and breathing out clean air. They soak up a lot of water in poor land and create a shelter for wildlife.

I was thirty years involved with trees. It was a good life for me. I reared a family doing something I like and that's a good thing to be able to say.

Acknowledgements

We gratefully acknowledge the generosity of all the owners of the shops and businesses included here. They welcomed us behind their counters and freely shared their stories with us, without them there would be no book.

A very big thank you to Dermot Healy for his inspiration and support to us in this project, also for his generosity in agreeing to write the foreword to the book.

A special gesture of appreciation is due to Oliver Luettringhaus for his ongoing visual support throughout the project and Babette Bangemann from Dusseldorf Art Academy.

Thanks to Laura Buckley for good advice at the beginning and Beth Amphlett for great editorial support at the end. Thanks also to Jane Marie Wastling, Margot Jones and S. Anthony and to our families, Oliver and Laszlo, Larry and Patrick, Pat and Kathleen who supported us throughout.

This is an opportunity to thank all the supporters of our inaugural 'High Shelves Long Counters' Exhibition 2010, Traolach O'Fionnain Arts Officer Donegal Co Council and the people of Mountcharles.

If you enjoyed this book, you may also be interested in…

Horse: The Horse and Irish Society
DAVID O'FLYNN

Throughout the ages the horse has played a pivotal role in Irish society. It is a ubiquitous symbol in Ireland, present in many classic depictions of our culture, from loyal work horse to traditional horse fairs. Over a twelve-month period, David O'Flynn has collected a varied selection of images of the Irish horse, in and discusses how the horse's role has mirrored the change in Irish culture as Ireland developed into a modern society.

978 1 84588 706 3

A Taste of Cork
SEÁN MONAGHAN AND ANDREW GLEASURE

Cork's rich and diverse landscape is renowned, but in this book one of Ireland's top photographers, Seán Monaghan, presents it in a new light, combining the spectacular vistas with the world of the artisan gourmet food producers who are so much a part of the culture. Seán Monaghan describes the motivations and method behind his photographs, while Andrew Gleasure recounts the individual stories of the people, giving a unique flavour of the county.

978 1 84588 714 8

Land Lust & Gun Smoke
PETER BACON

The history of game shoots in Ireland is more than a sporting catalogue or a monument to privilege; it is a vibrant record of the changing face of a country and a society. For some it was the theatre in which alliances were forged, marriages made and economic ties strengthened; for others it was a primary source of employment and a mainstay of everyday life. These aspects and more are explored in this book, set against the background of the richly coloured world of the Ascendancy at play.

978 1 84588 717 9

Visit our website and discover thousands of other History Press books.

www.thehistorypress.ie